D1470307

Yellowstone & Grand Teton

WILDLIFE PORTFOLIO

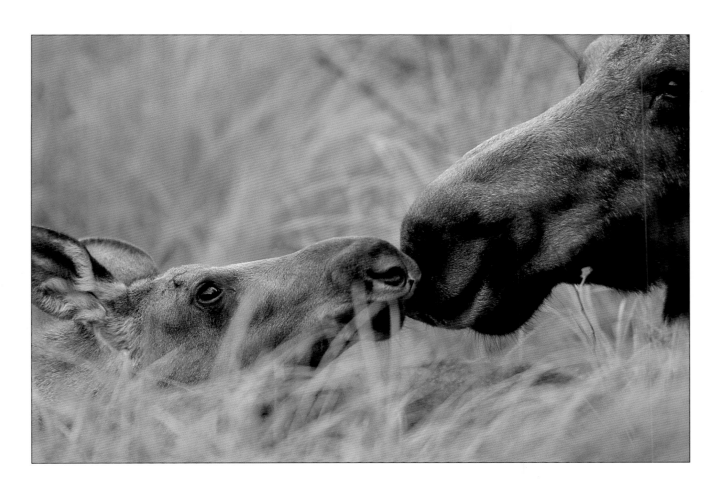

by HENRY H. HOLDSWORTH

FARCOUNTRY
PRESS

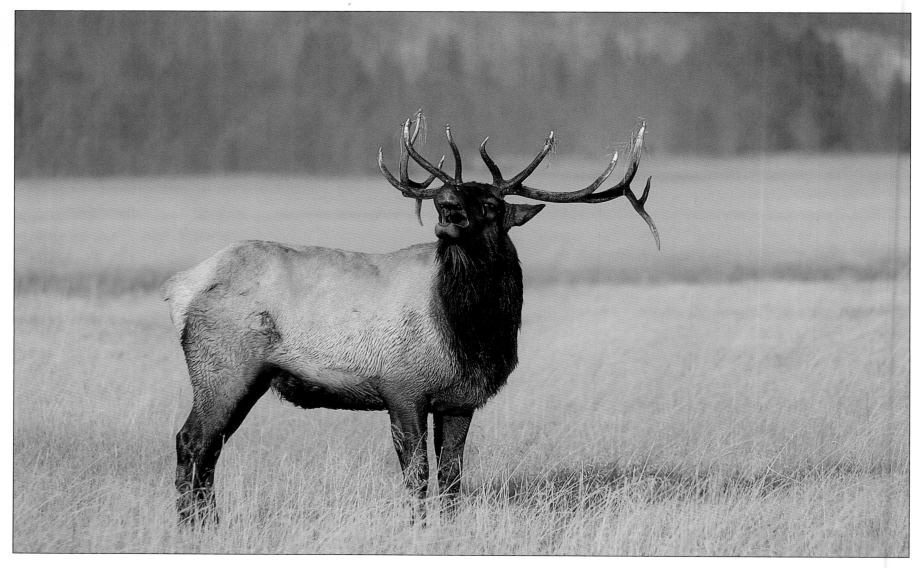

ISBN: 1-56037-177-3
© 2001 Farcountry Press
Text and photography © 2001 Henry Holdsworth

Farcountry Press, P.O. Box 5630, Helena, Montana 59604, (406) 443-2842, or (800) 654-1105

Book catalog appears online at www.farcountrypress.com

Printed in Korea

Above: The bull elk's bugling call, a loud whistle-like sound, advertises its presence to other bulls as they gather harems during the rutting season, late September through mid-October.

Page one: This moose calf will remain under Mother's watchful eye for the first year of its life, being protected from predators such as coyotes, wolves, and grizzlies, and being taught the ways of its world.

Facing page: Sandhill cranes are one of the oldest bird species known to man, and their prehistoric cry can be heard throughout the parks in summer. Each year they arrive in late March or early April to nest in marshes as they have done for hundreds of thousands of years.

Front cover: Spirit of the buffalo: five bulls in a thermally heated creek not far from Old Faithful. A steambath is the Yellowstone way to deal with the onslaught of a February blizzard.

Back cover: Moose calf (top), and nesting Canada Goose with hour-old chicks (bottom).

Foreword

In the rugged mountains of Idaho, Montana, and Wyoming, high atop the Continental Divide, lies a land of unparalleled beauty and unimaginable natural wonders. It is an area unique in all the world. A land of amazing geysers and hot springs, of deep and colorful river canyons, of crystal clear lakes and incredible waterfalls, of jagged snow-capped peaks and pristine forests. It is a land born of volcanoes and glaciers, of forest fires and deep cold winters, a land that is constantly changing and evolving, a land shaped by fire and ice. But for all the incredible scenery and grandeur this place has to offer, the abundance and diversity of its wildlife set it apart. The landscape alone will keep you coming back time and time again. It is also the sounds and the colors of the creatures that inhabit this high country treasure, that bring life to the mountains and valleys we call Yellowstone and Grand Teton national parks.

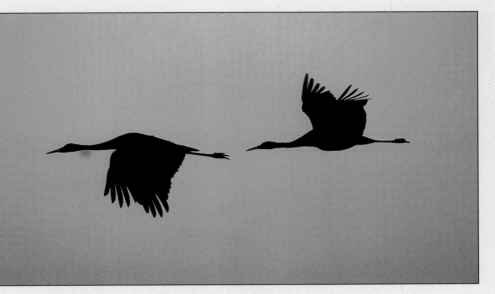

Yellowstone and Grand Teton are two of the jewels in the national park system. Yellowstone was the world's first national park, and is the largest park in the continental U.S. covering some 2.2 million acres. It is larger than the states of Rhode Island and Delaware combined or two-thirds the size of Connecticut. It is a park teeming with wildlife. It is one of the last strongholds for the grizzly bear in the lower forty-eight states. It holds the one of the last free roaming herd of bison. It was a safe haven for the rare and graceful trumpeter swan when it was hunted to near extinction for its beautiful feathers in the early 1900s. And it is summer home to the largest concentration of elk in North America. But for all its size, Yellowstone is simply not big enough to hold all its wildlife inhabitants, for the creatures travel freely across the park boundaries man has placed on the map. These boundaries did not take into consideration ancient migration routes and wintering grounds, but we now see the park as just a part of a much larger entity. This larger entity is what we now call the Greater Yellowstone Ecosystem.

The Greater Yellowstone Ecosystem is a vast area covering over 14 million acres. It runs from the southern tip of the Wind River Mountains to Butte, Montana, and from north of Billings to Bear Lake just above the Utah border. It is the largest, relatively intact, temperate ecosystem in the world. And its life's blood is the incredible wildlife that binds the ecosystem together, a diverse and interdependent array of organisms that flourish in this extraordinary environment. Nowhere will you find a greater display of wildlife in its element than at the heart of the ecosystem, Yellowstone and Grand Teton.

To travel into the parks is to travel back in time. To open a window to the past through which we can view the natural order as it has existed for eons. For it is here, like few other places, you can experience the earth on its most primitive terms. A journey into the back country is a journey to a place where man is not king. Large predators still dominate the food chain, and Mother Nature rules with an iron fist. You can see grizzlies hunt, hear wolves howl, and if extremely lucky catch a glimpse of a mountain lion and her playful kittens. The Greater Yellowstone Ecosystem is as wild a place as you can find in the continental U.S., a place that represents the true meaning of the word wilderness. It is a place where a change of season brings a whole new reason to visit old haunts. Where spring meadows burst with wildflowers and the calves of elk and bison. Where summer might bring a private encounter with a mule deer and fawn or a cow moose and her twins. Where the bugling of elk sounds the coming of fall as the nights grow colder and the trees start to turn. Where the onset of winter brings a blanket of snow transforming the parks into a dreamlike wonderland where only the hearty survive. For it is here, in Yellowstone Country, that you can still watch the drama of nature unfold, as it has since the dawn of time.

So sit back and relax and let your mind wander, as this book takes you to the place where these visions are possible. A place that is forever wild.

—*Henry H. Holdsworth*

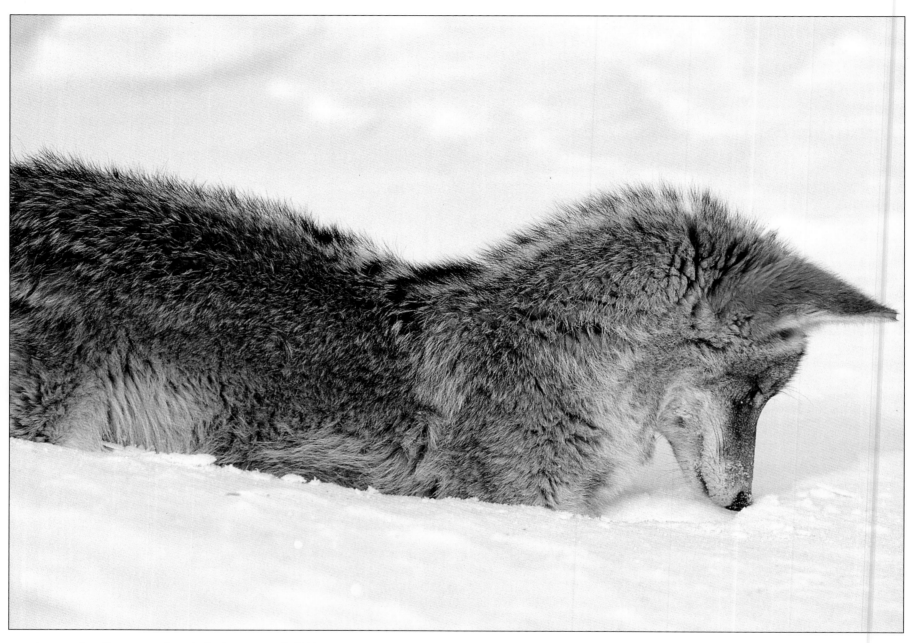

A coyote dives for a mouse through the deep snows of a Yellowstone winter. Mice, along with winter-killed elk and bison, make up a large part of the coyote's diet during this season.

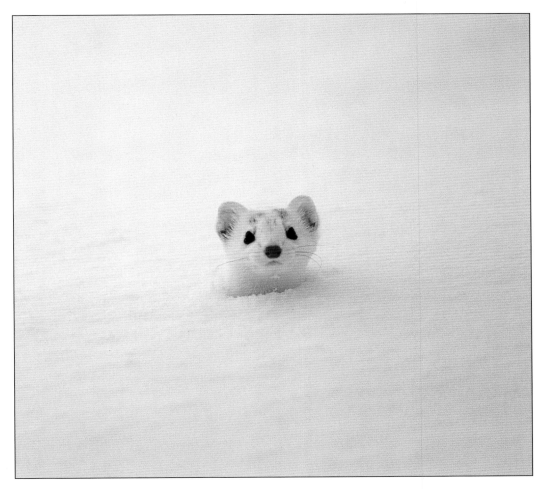

Hunting for mice in Grand Teton by following through their trails in the snow, a short-tailed weasel is perfectly camouflaged for this time of year. In the summer he will turn brown to match his surroundings, but for now he remains white, except for the black tip of his tail, and goes by the name ermine.

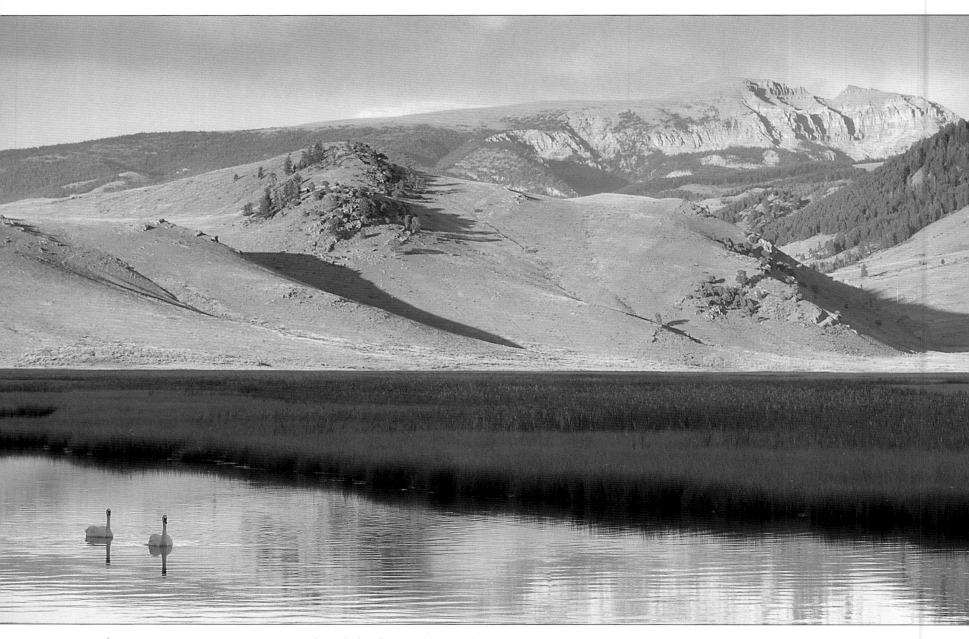

A pair of trumpeter swans enjoys a summer evening beneath the Sleeping Indian on the National Elk Refuge. The species was hunted to near extinction in the early 1900s, and only 69 swans remained in this area by 1935. The remote valleys of the Yellowstone region protected the birds, which now number close to 350 individuals.

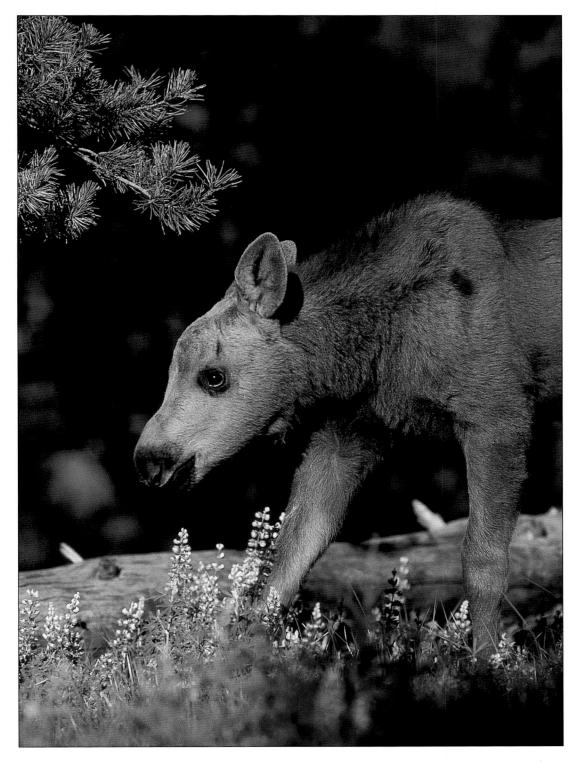

Two weeks old, and out for a stroll through a patch of lupine near Yellowstone Lake. Born in late May or early June, moose calves often can be seen in early morning or late evening near Bridge Bay or Fishing Bridge, or along Pelican Creek. In the Tetons, Christian Creek and Willow Flats are the best places to find them.

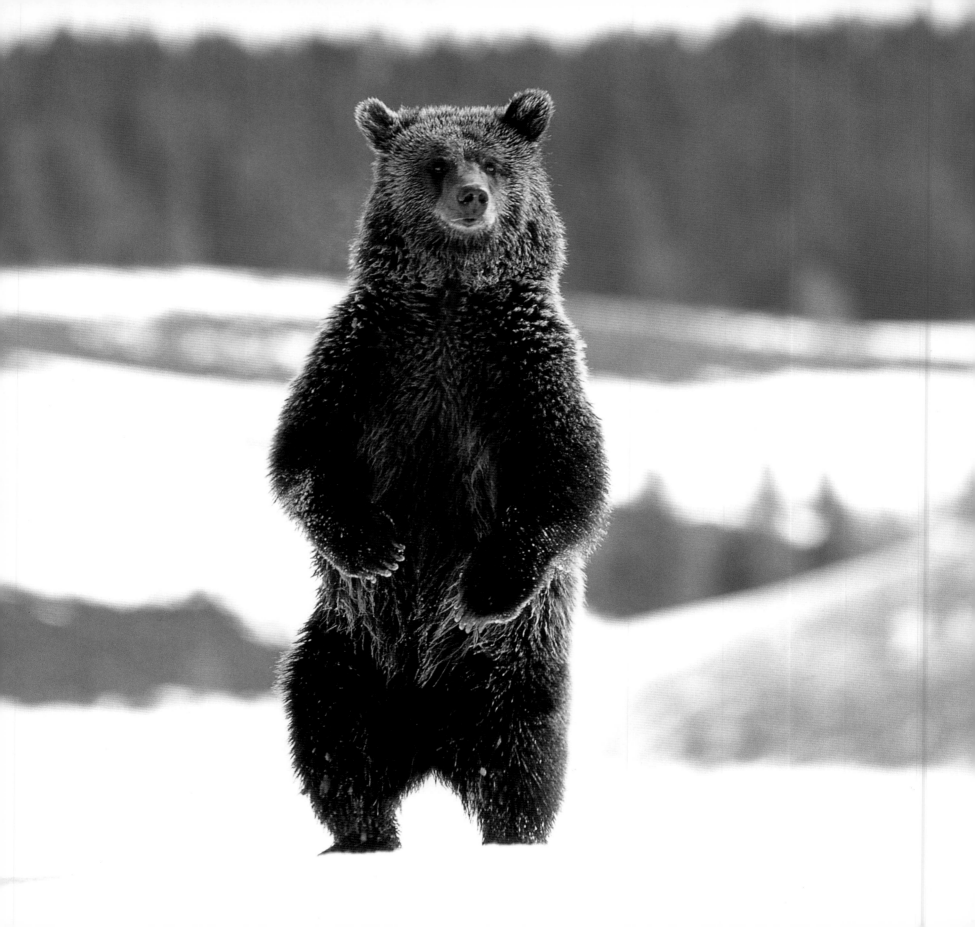

Right: The tracks of a snowshoe hare mark its passing through an aspen forest. Though the hares are seldom seen due to exceptional white camouflage and nocturnal habits, their tracks show up throughout the winter in meadows and forests of the Yellowstone Ecosystem.

Below: Evergreen bark makes a porcupine's breakfast. Found throughout the forests of the region, porcupines protect themselves by releasing their sharp quills at predators. (RICK KONRAD PHOTO)

Facing page: Upon emerging from his den in late March or April, this grizzly began scouring meadows and river bottoms—and here the rolling sagebrush hills of Hayden Valley—in search of food after his long winter nap. (ED & BOBBIE TAYLOR PHOTO)

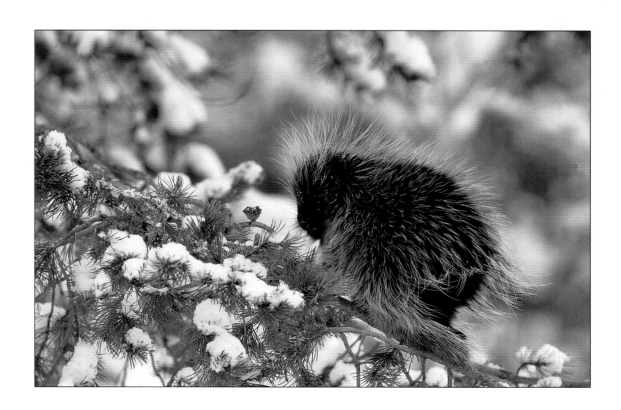

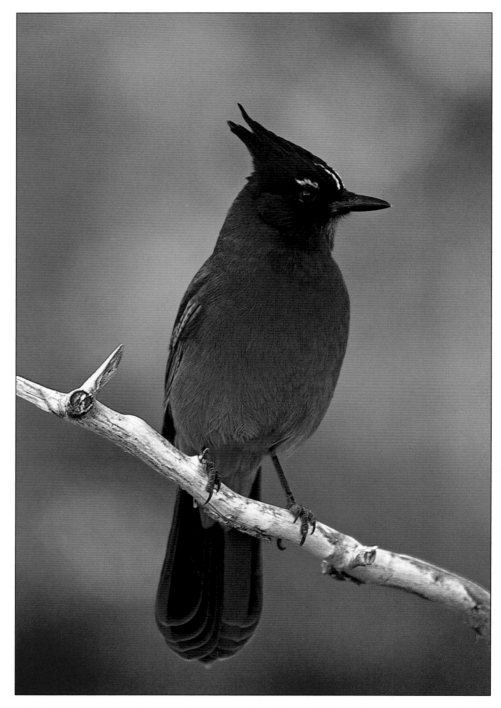

A Steller's jay poses at the edge of an evergreen forest. These colorful and sometimes raucous birds spend much of the summer at higher elevations deep in the mountains. Steller's jays, and their cousins gray jays, often join back-country hikers on their lunch stops.

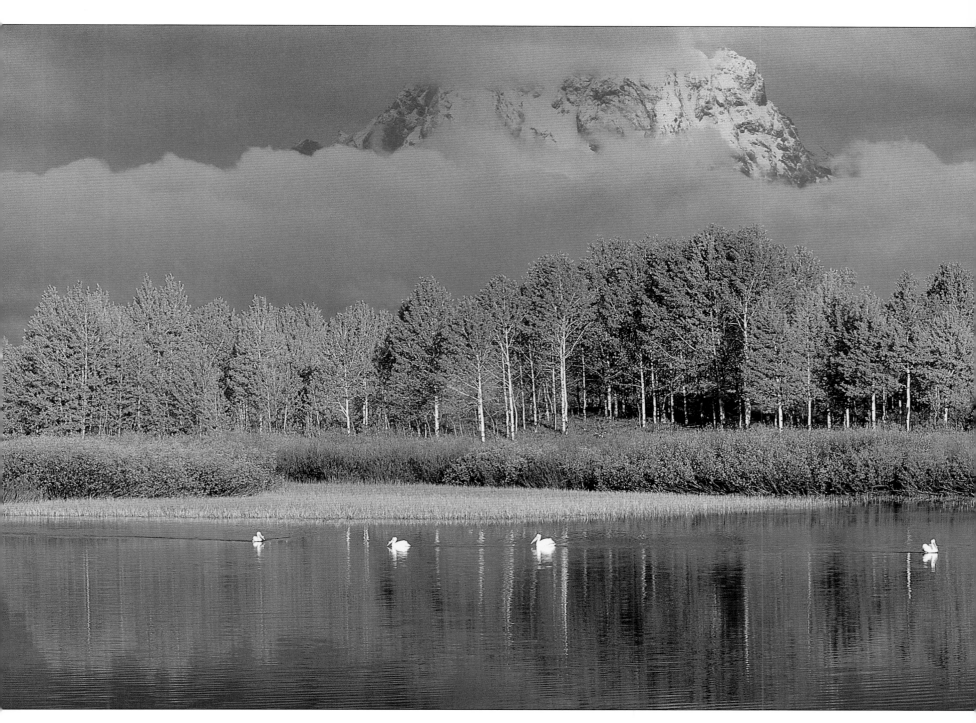

White pelicans meander on the placid waters of the Oxbow Bend of the Snake River while the dark clouds of an early September snowstorm cloak Mount Moran. The pelican is not a bird people expect to see in the mountains, but pelicans prefer summer nesting sites on interior lakes. The remote southern arm of Yellowstone Lake is home to a breeding colony.

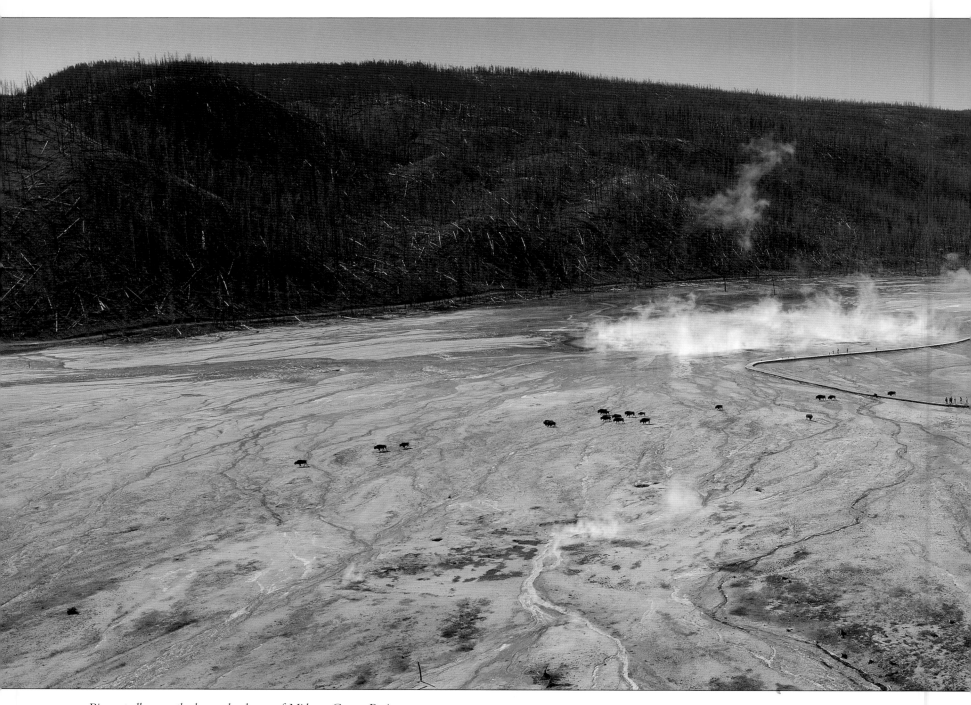

*Bison stroll across the barren landscape of Midway Geyser Basin
in the heart of Yellowstone Park.*

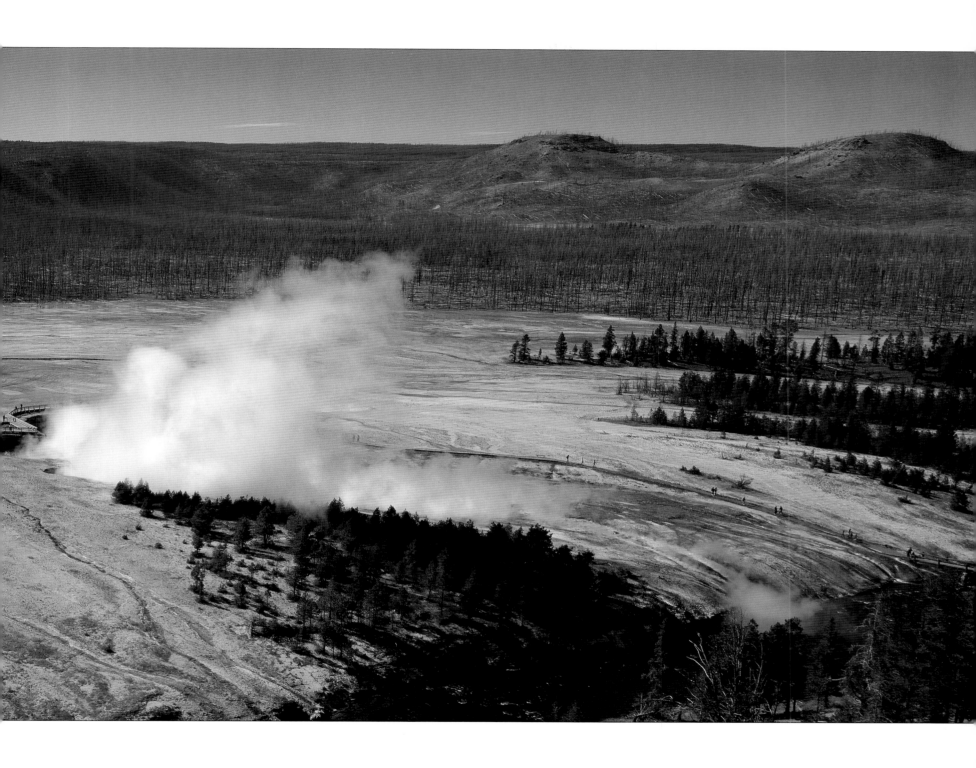

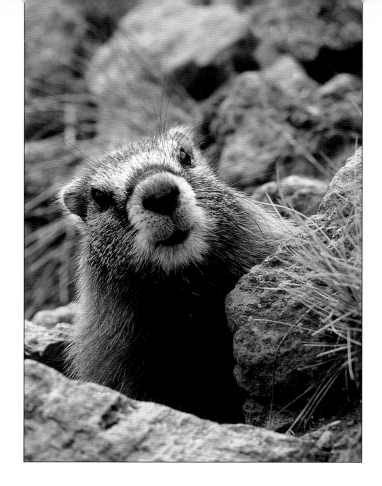

Also called "rock chuck" or "whistle pig" for its loud shrill call, the yellow-bellied marmot, a large member of the rodent family, summers on rocky slopes and hibernates in winter.

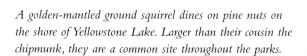

A golden-mantled ground squirrel dines on pine nuts on the shore of Yellowstone Lake. Larger than their cousin the chipmunk, they are a common site throughout the parks.

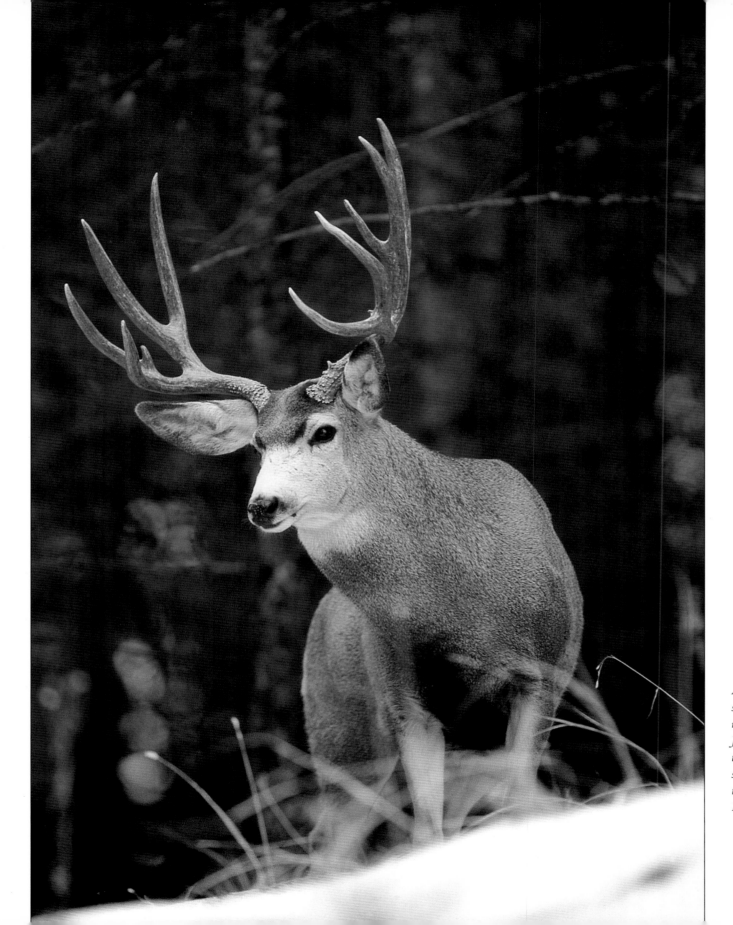

A mule deer buck searching for does near Tower Junction during the fall rut season, November through mid-December.

15

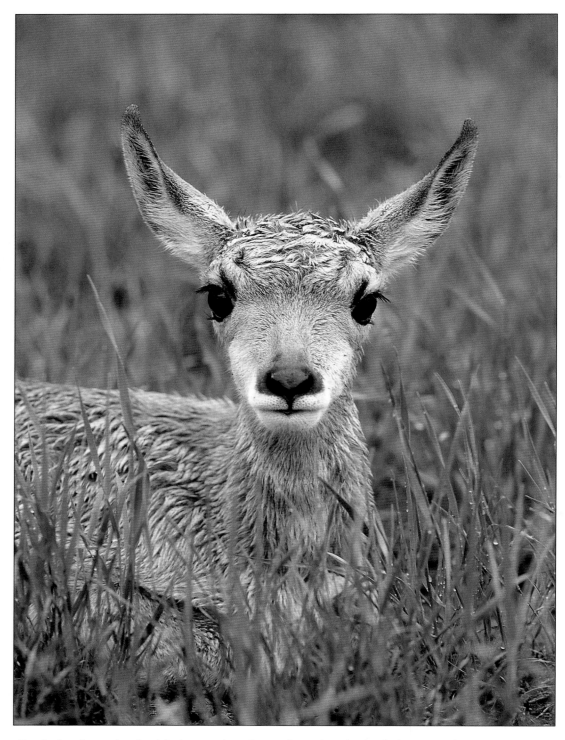

For the first few weeks of its life, this pronghorn fawn will spend much of each day, rain or shine, concealing itself from predators such as coyotes.

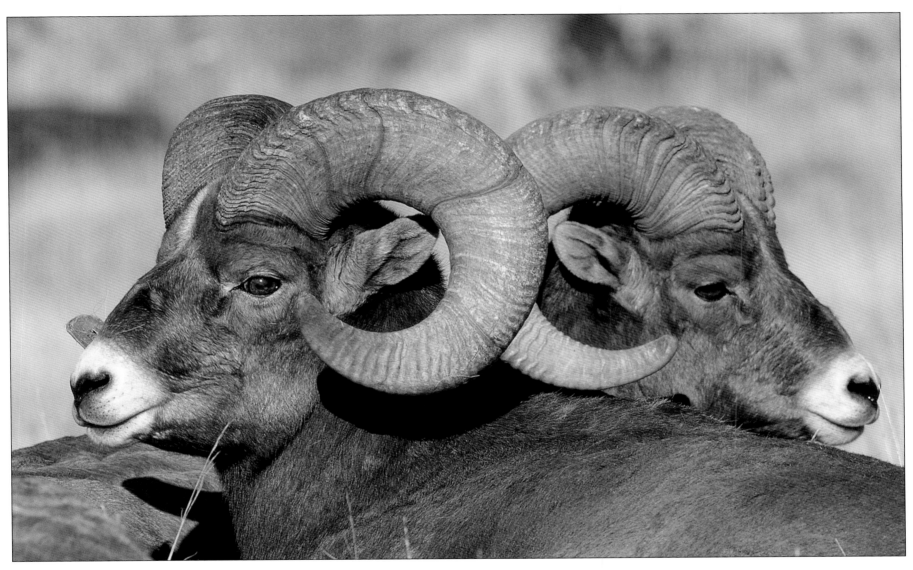

Bighorn sheep rams mingle on the slopes of Mount Everts in northern Yellowstone. Although they spend most of the summer months high in the mountains, sometimes they travel to the Gardner River Canyon north of Mammoth Hot Springs, or climb Mount Washburn.

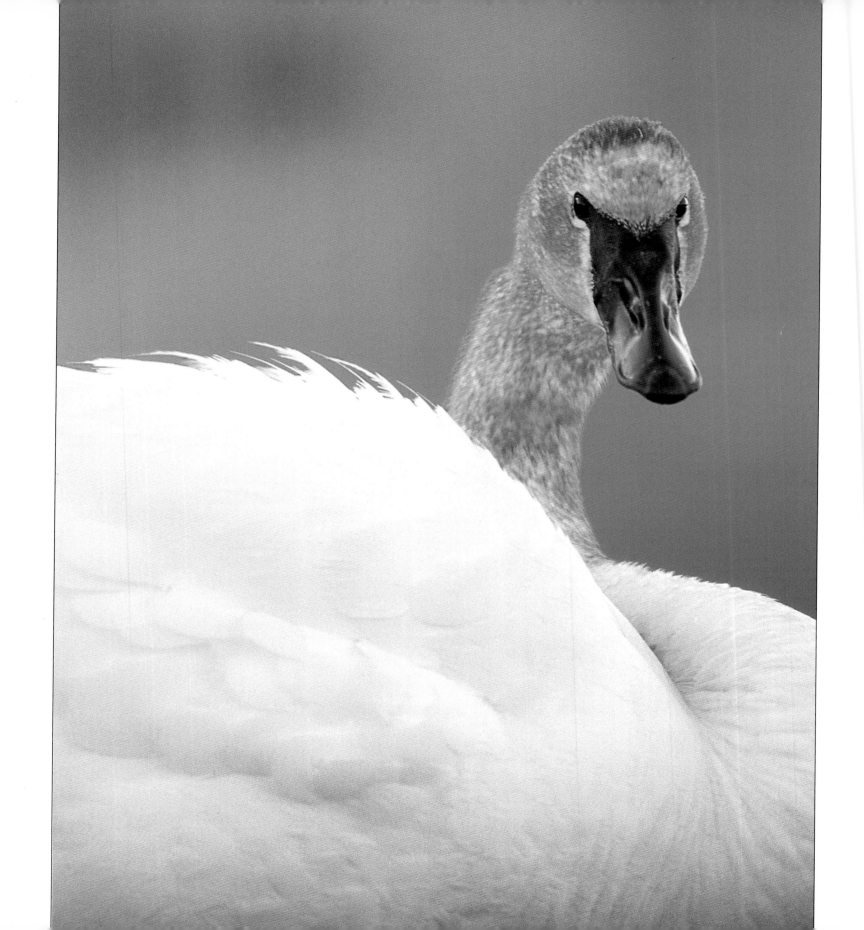

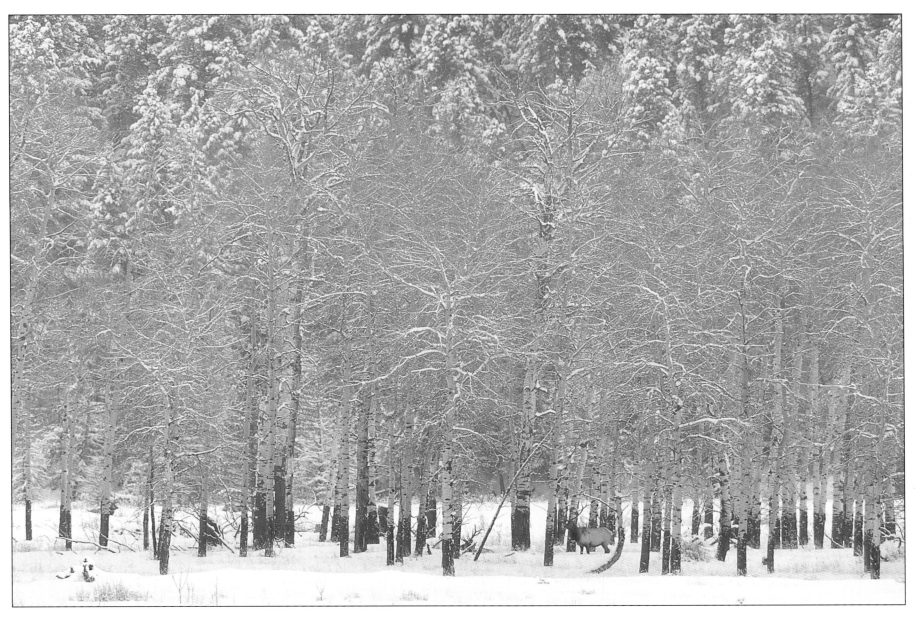

Above: Aspens shelter wintering elk, and their twigs and bark provide emergency forage. Tree trunks in areas heavily used by elk show chew marks.

Facing page: As this young trumpeter swan—preening along the banks of Flat Creek on the National Elk Refuge—matures, he will lose the reddish coloring on top of his head and become pure white.

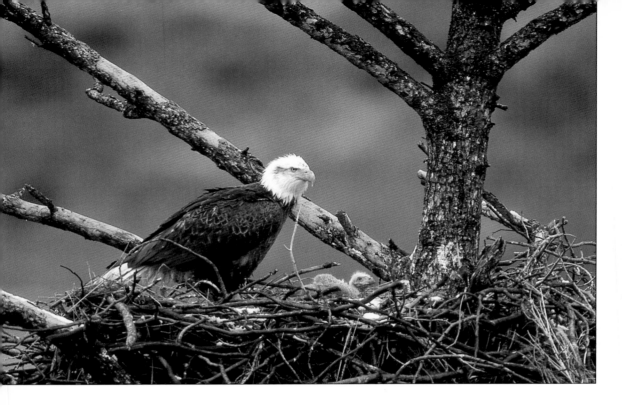

A bald eagle tends to her two-week-old chick during a late April snow shower. The Greater Yellowstone region harbors a healthy population of nesting eagles who fish its many pristine lakes and rivers.

With many a load of willows, this beaver will spend most of summer repairing its lodge and dam in preparation for the long winter ahead.

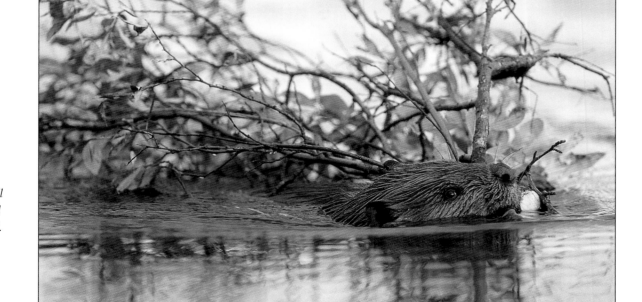

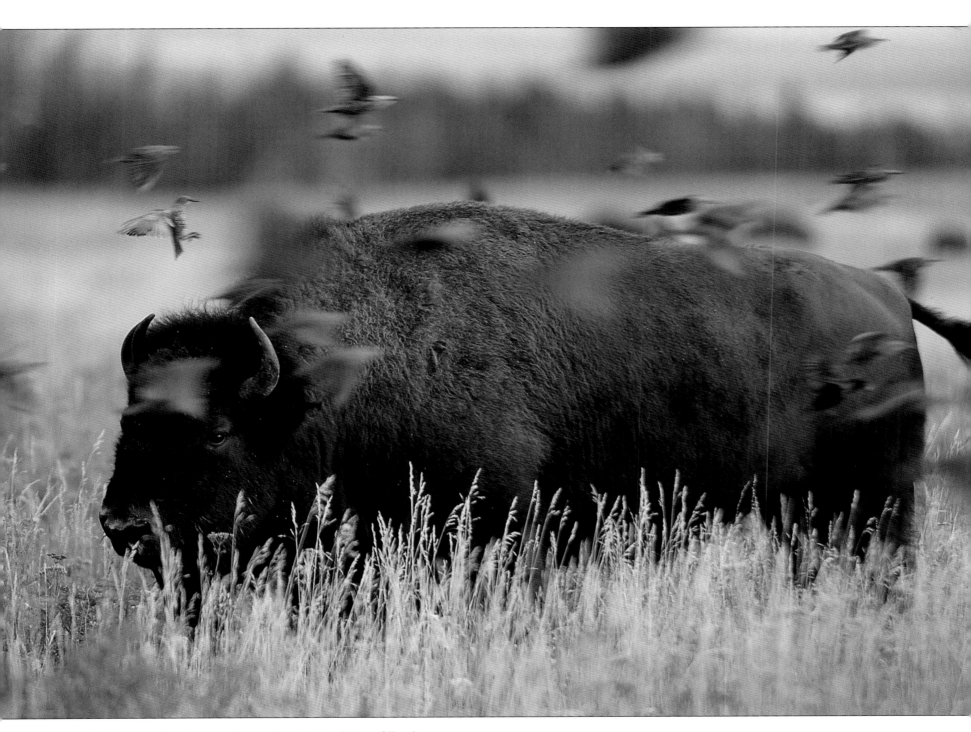

Starlings, here fluttering around a cow bison in Grand Teton, follow bison herds to feast on insects that rise from tall grasses and sagebrush fleeing the large mammals' hooves.

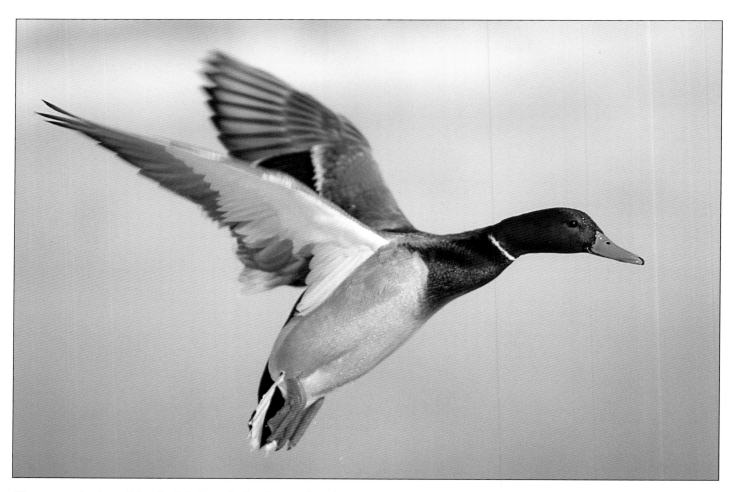

The common but beautiful mallard duck can be found in ponds and streams at lower elevations.

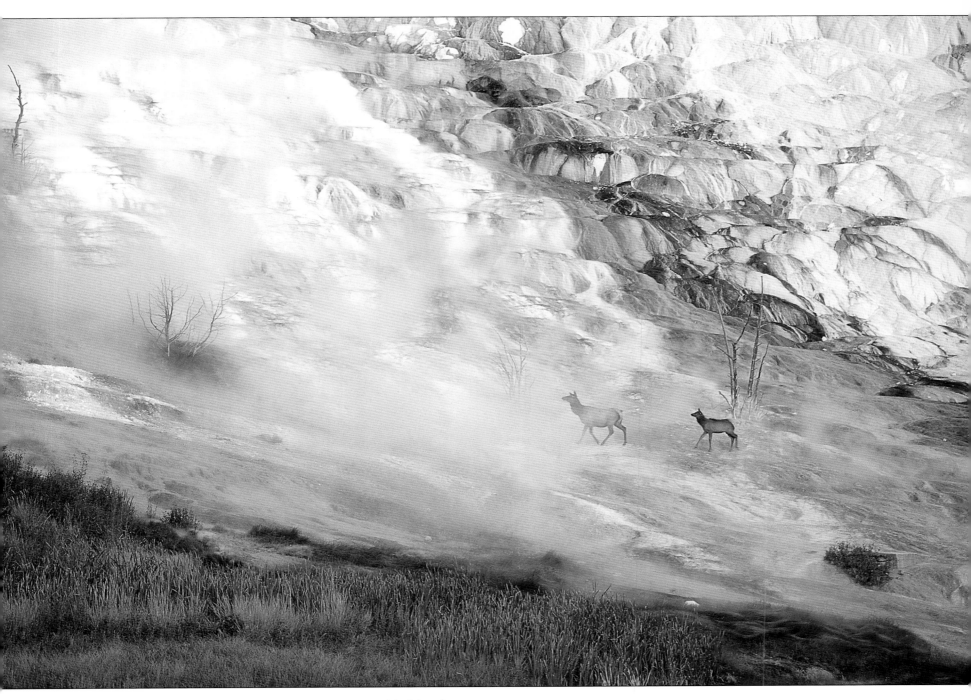

Canary Springs and the green of summer grasses offer a magical backdrop for a cow elk with calf in tow. The shifting waters of Mammoth Hot Springs are constantly changing the look of this giant travertine terrace.

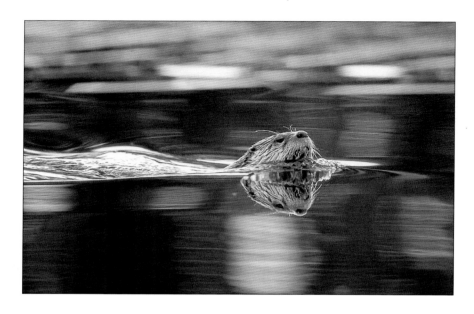

Above: A river otter on patrol at Oxbow Bend of the Snake River, Grand Teton National Park. In Yellowstone National Park, West Thumb and the Madison River are the best places to glimpse this elusive species.

Right: The Tetons loom behind a large bull moose as he struts his stuff out in Willow Flats.

Below: A common loon "penguin dances" atop the water during his mating display. Loons may be seen at Oxbow Bend in Grand Teton during early spring, before heading to back-country ponds for nesting. Their eerie call is one of the most wonderful sounds in nature.

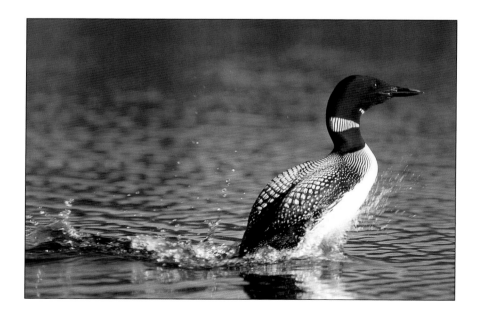

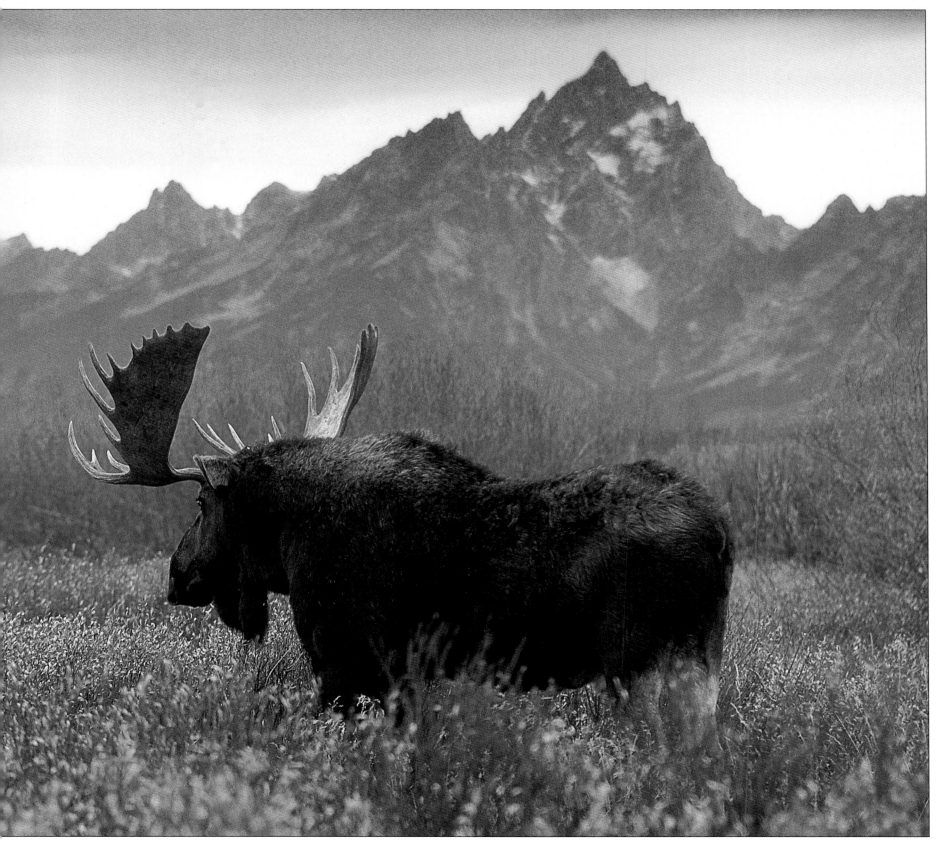

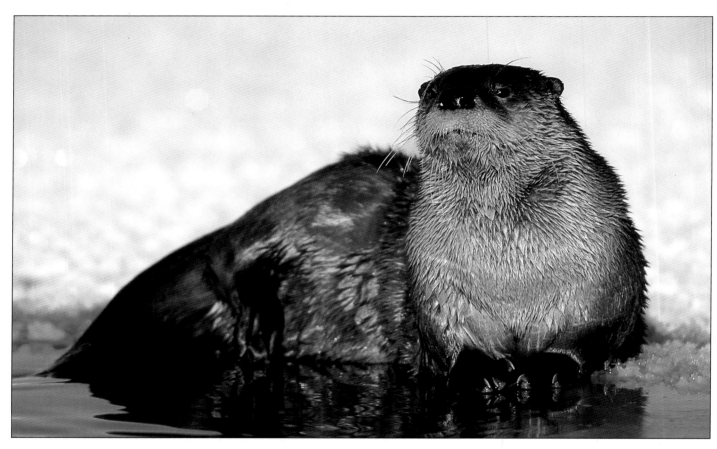

A master fisherman, this river otter lounges at Blacktail Ponds in northern Yellowstone Park. The species is among the most funloving and playful animals. (SCOTT McKINLEY PHOTO)

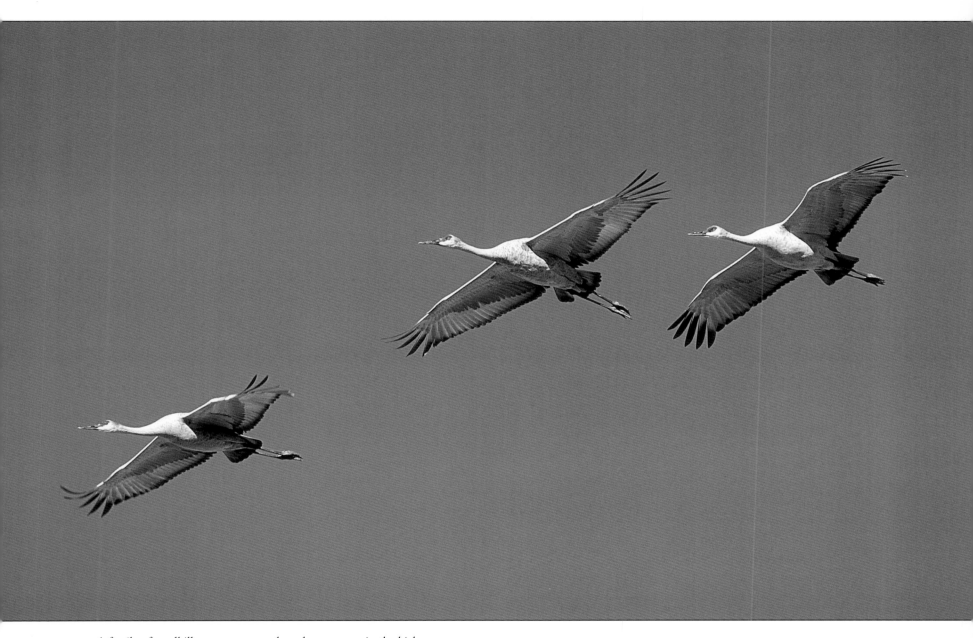

A family of sandhill cranes soars southward as summer in the high country draws to a close. This year's chick, now fully grown, is ready to follow his parents to their wintering grounds on the Rio Grande River in New Mexico.

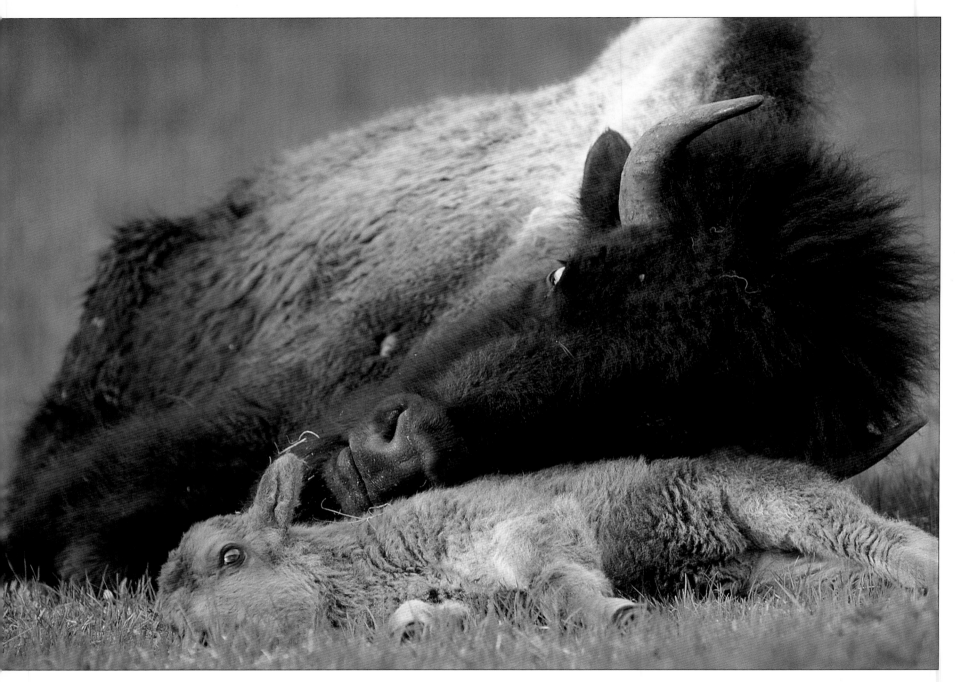

Like most new parents, this mother bison along the Madison River was so tired she couldn't keep her eyes open. Each time she dozed off, her heavy head came crashing down on the poor sleeping calf. After this scenario was repeated several times the wise calf moved out of range.

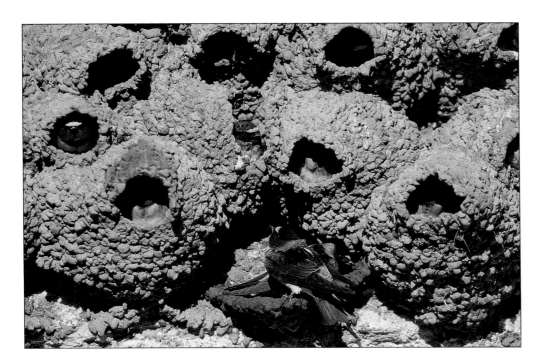

Cliff swallows busily finishing their mud nests at Soda Butte. Other species of swallow that summer in the parks include bank, barn, tree, and the beautiful but rarely seen violet-green swallow.

Pikas are cute little inhabitants of talus slopes and alpine meadows that chirp sharply at hikers happening by. Unlike most small mammals found at high altitudes, the pika does not hibernate. It works steadily all summer drying grass in piles, which sustain it through the long, snowy winter.

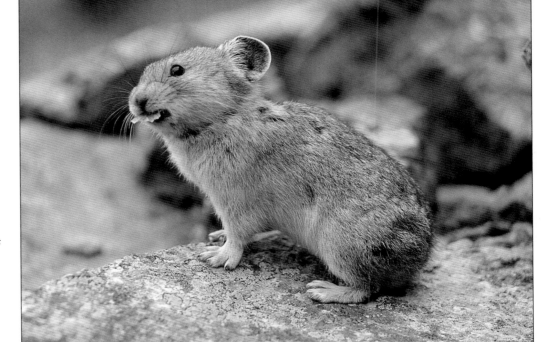

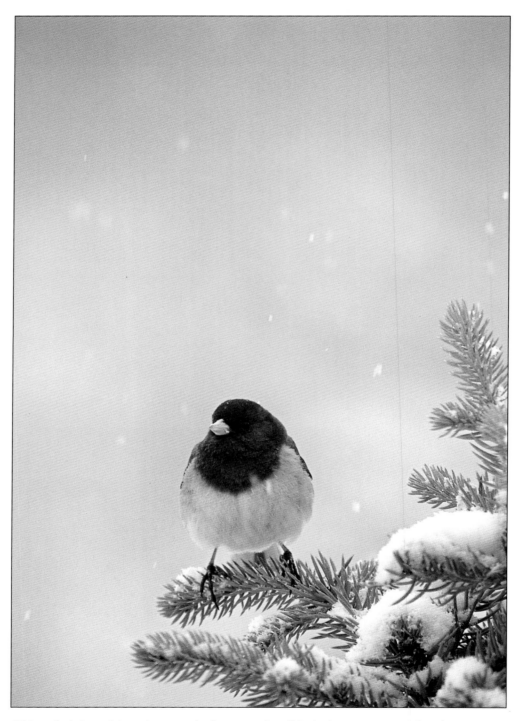

This male dark-eyed junco is among the few types of small birds that stay year-round in the area, migrating to lower elevations during winter.

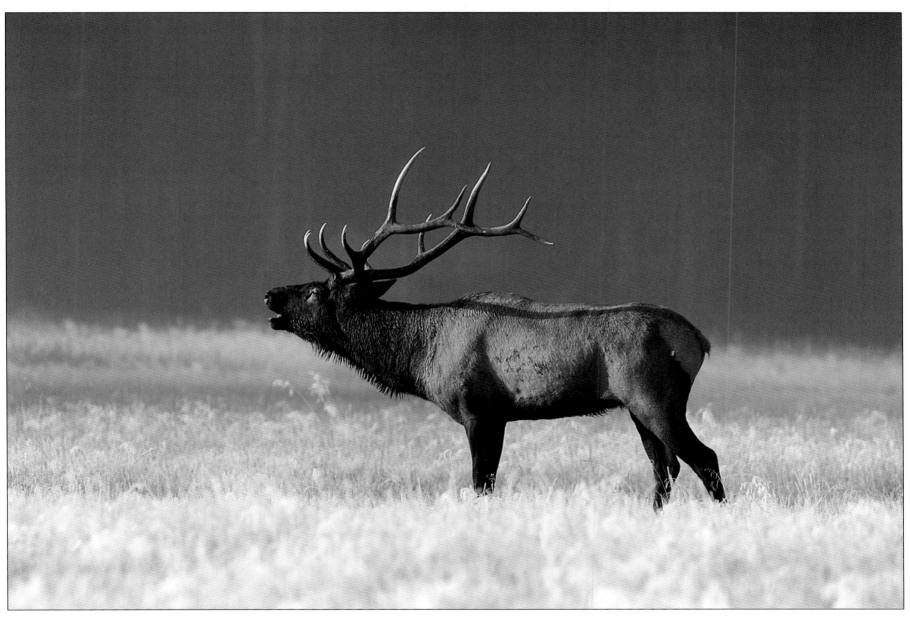

On a frosty October morning, a bull elk's bugling call rings eerily.
It is not uncommon for the temperature to reach zero degrees
Fahrenheit during clear fall nights in the parks.

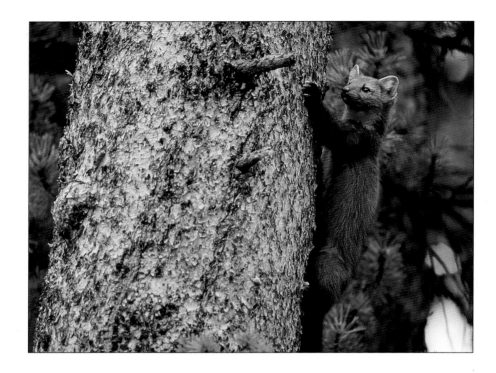

Clinging to a lodgepole pine, this pine marten keeps wary eyes on a nearby great gray owl, one of its predators. Martens themselves spend most of their time hunting squirrels, birds and rodents in dense evergreen forests. (RICK KONRAD PHOTO)

To snag its dinner of cutthroat trout, this osprey hovered high above the target, then plunged rapidly with talons ready. Because they live almost exclusively on fish, they are also known as "fish hawks."

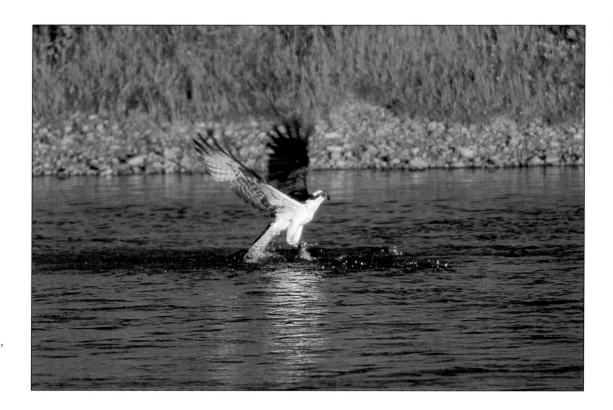

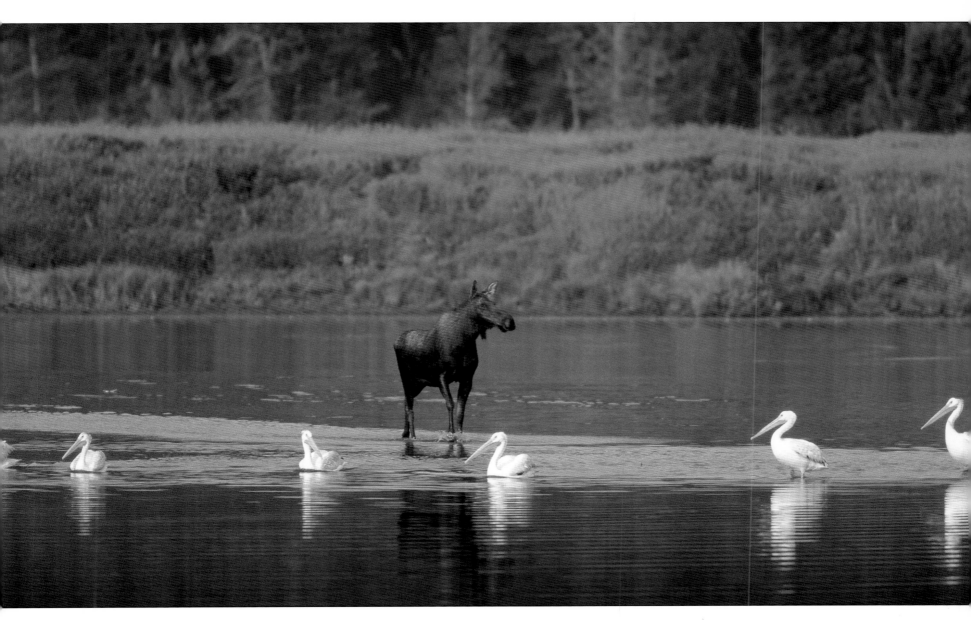

Getting your ducks in a row. An agitated cow moose decides to chase a flock of white pelicans from their sandbar on Oxbow Bend. Moose are very unpredictable creatures—just ask any pelican.

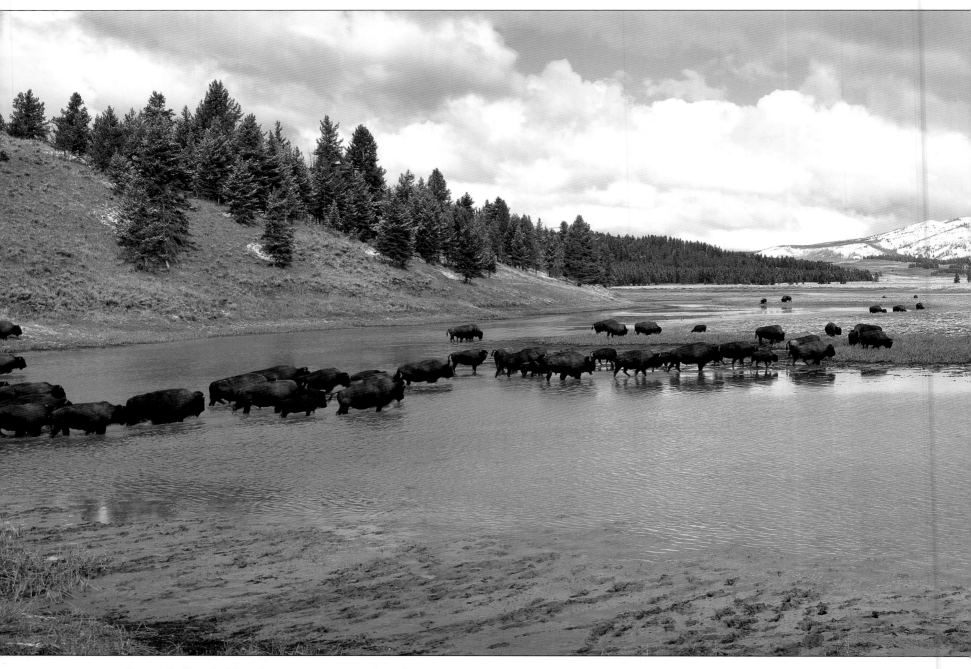

Bison wading a side channel of the Yellowstone River in Hayden Valley. Yellowstone's 2,500 head are part of the largest free-roaming group left in North America. They give give only a glimpse of what the great herds must have looked like when an estimated 20 to 60 million bison roamed the Great Plains.

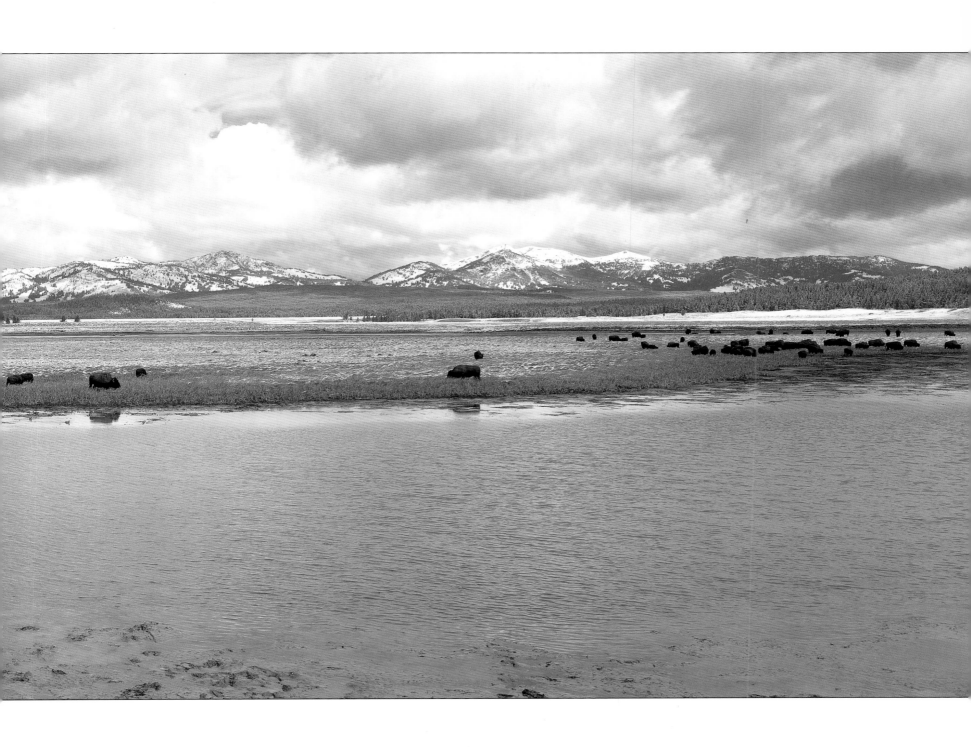

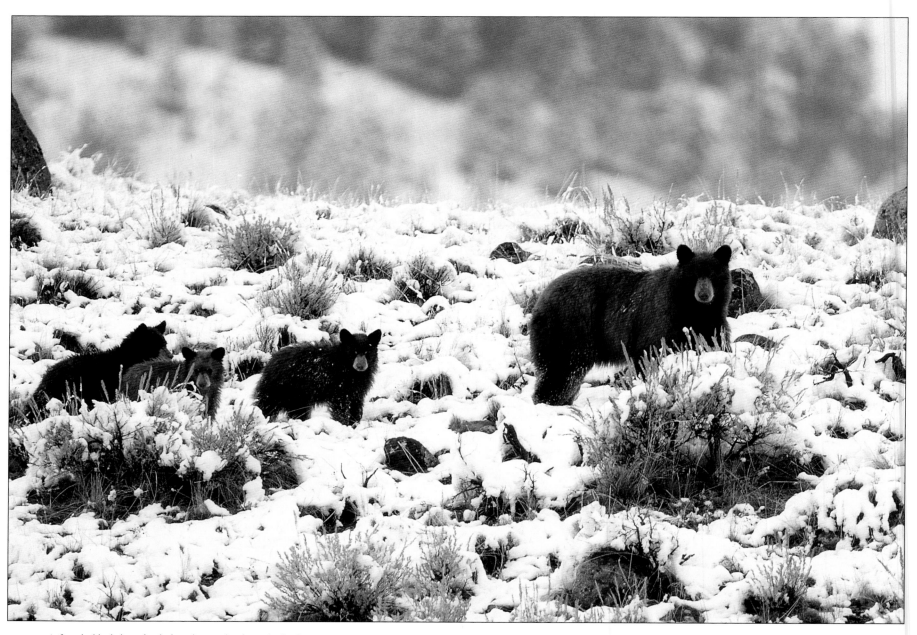

A female black bear leads her three cubs through the Lamar Valley, probably heading for their winter den. Black bears can have cinnamon, brown or black fur. (SCOTT McKINLEY PHOTO)

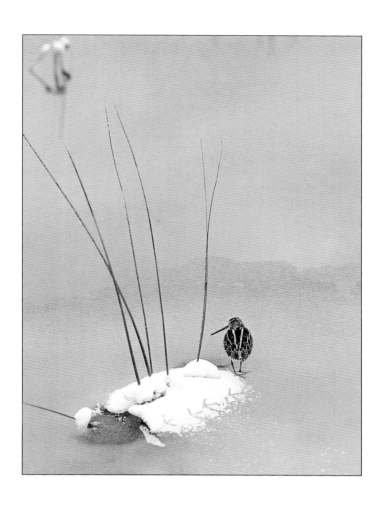

A common snipe, more often heard than seen, on the frozen edges of the Madison River. During their mating season, they fly in circles and dive, using their tail feathers to create a high-pitched hum or whistle. The wonderfully unique sound brightens spring evenings.

A male blue grouse fluffs up on top of Signal Mountain in Grand Teton National Park. Both here and the slopes of Yellowstone's Mount Washburn are excellent places to view this bird during its spring mating ritual.

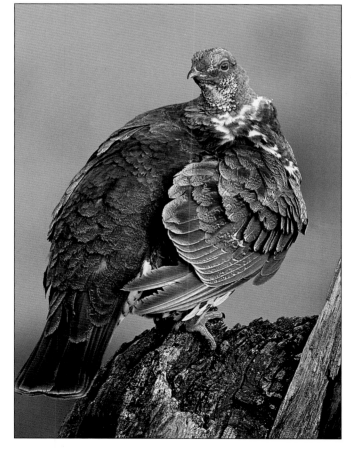

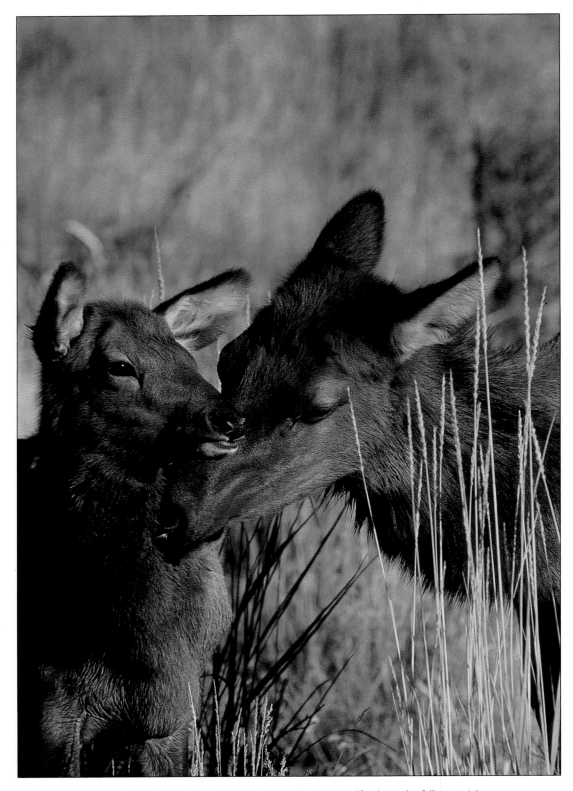

This nurturing cow elk and her calf will stay together until her next calf is born the following May.

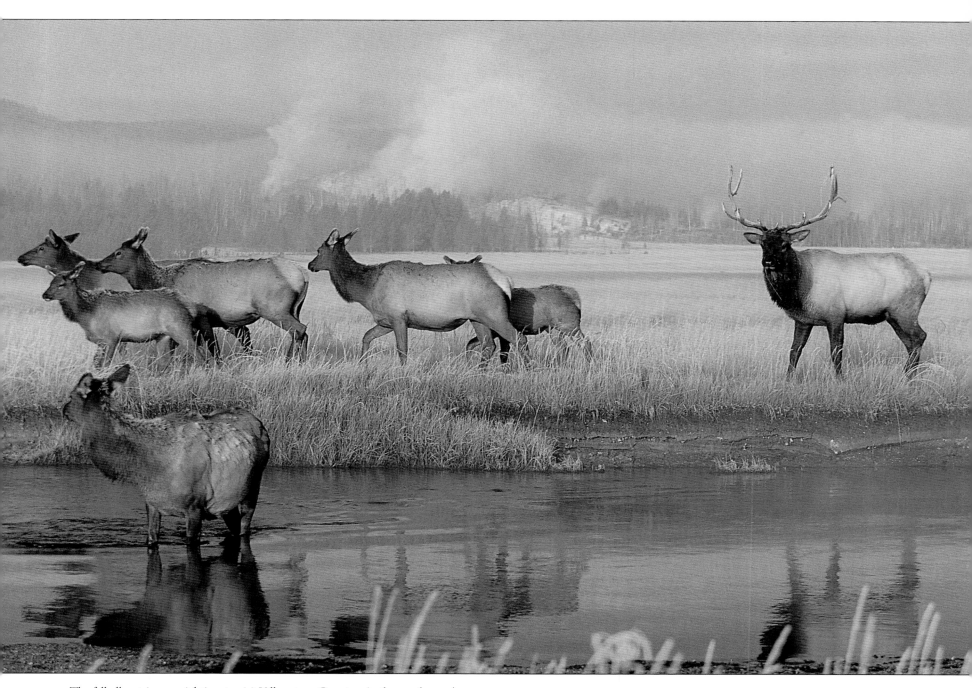

The fall elk rut is a special time to visit Yellowstone Country. As the weather cools, activity heightens—as here along the Gibbon River—and bulls bugling among their harems can be heard mornings and evenings through both parks.

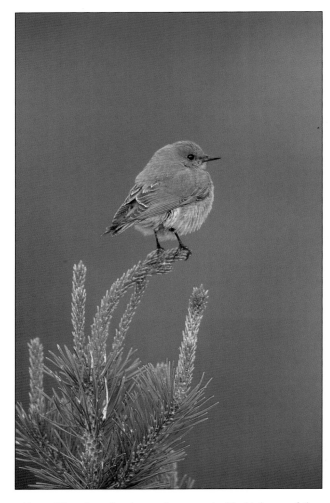

Above: First sign of spring: male mountain bluebird, one of the earliest and most colorful migrants to reach high country each year.

Right: These bachelor bull moose at Oxbow Bend probably summered together. The picture was taken in early September just after the bulls had shed the velvet from their antlers. Soon they would head their separate ways as the rut began.

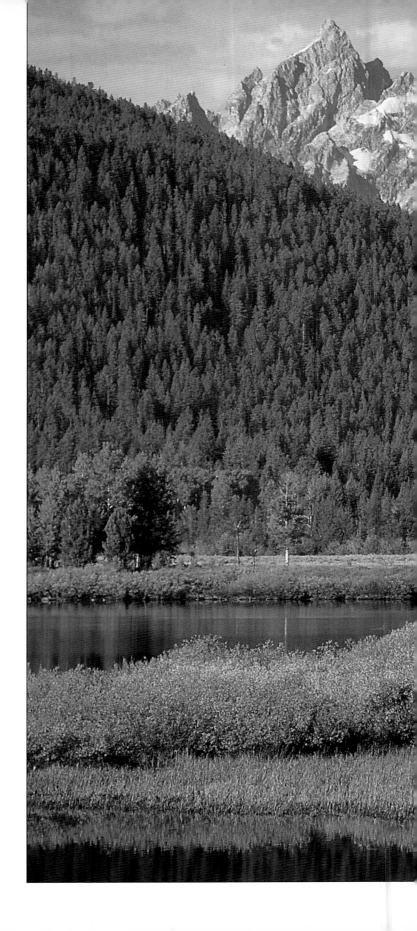

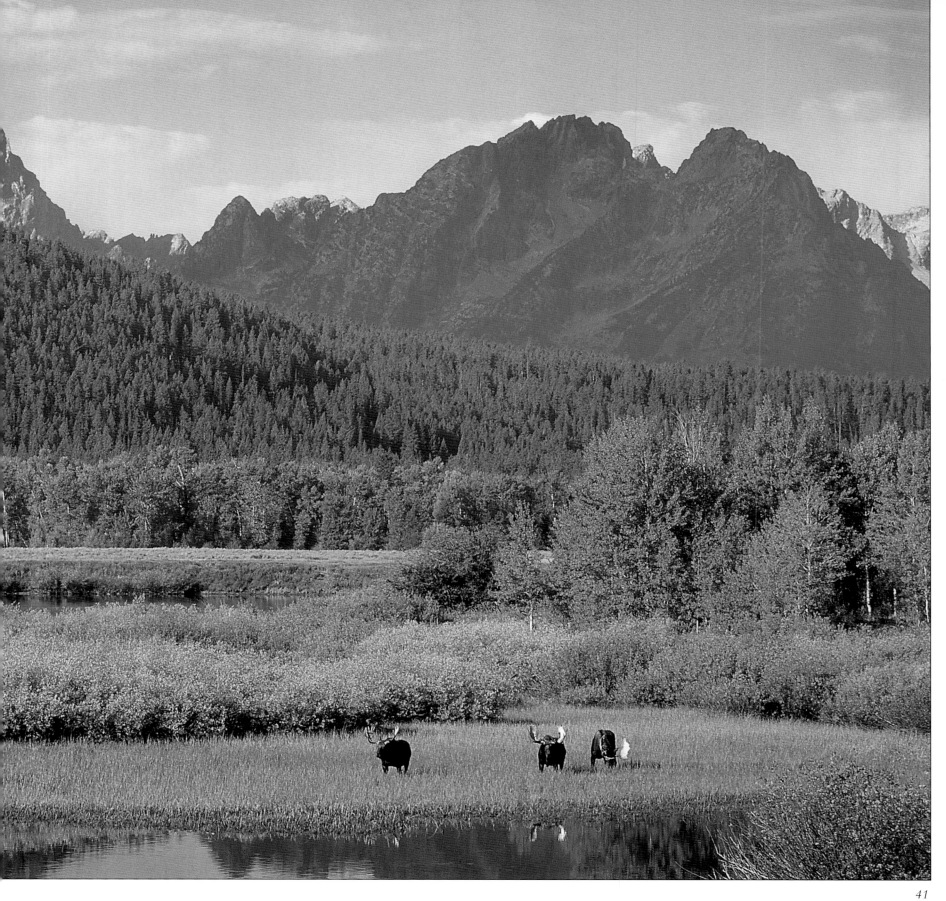

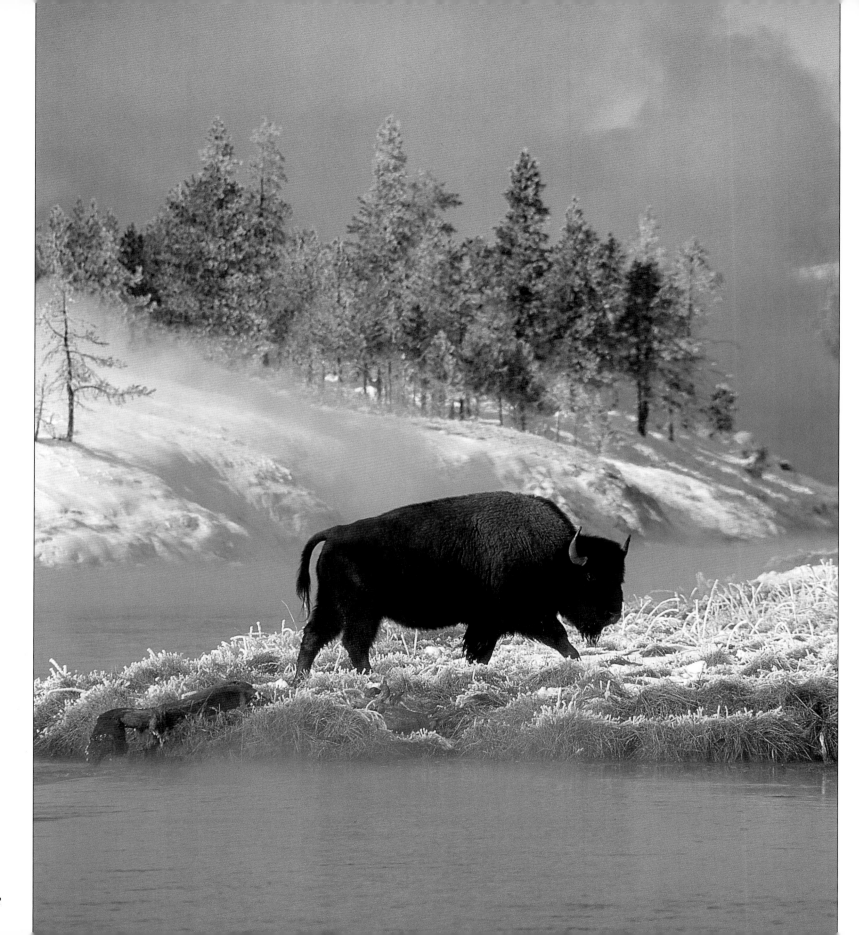

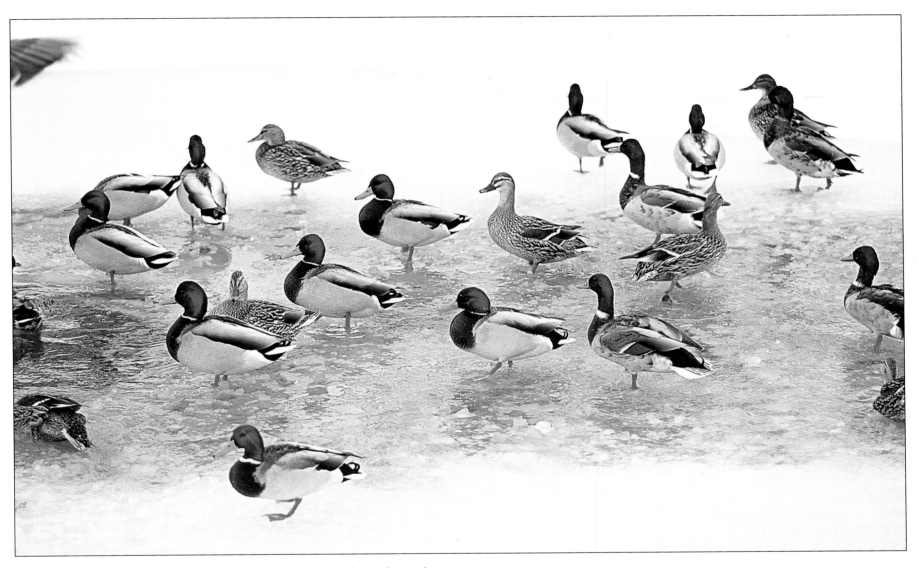

Above: This gaggle of mallards on Flat Creek in Jackson Hole may be wondering where the open water went overnight. Mallards, along with Barrow's goldeneyes and common mergansers, are among the few species of duck that tough out the mountains' cold winters.

Facing page: Only the hearty survive Yellowstone's harsh winters. On this morning the temperature was 25 degrees below zero Fahrenheit, but the mercury can dip to 60 or more below in an extended cold snap. Beyond this bull bison at the Firehole River looms the steam of Midway Geyser Basin.

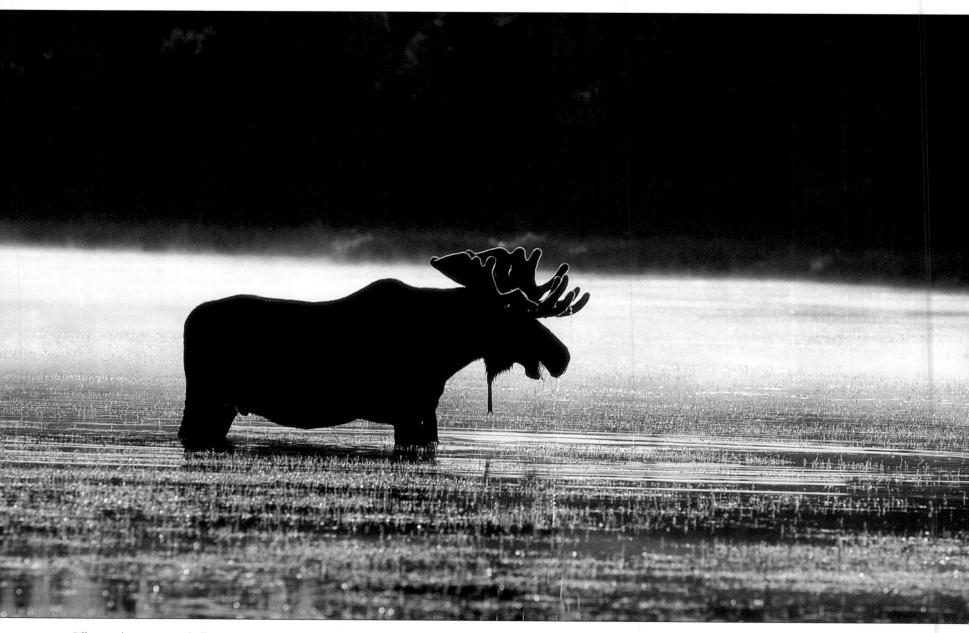

Silhouetted at sunrise, a bull moose enjoys a breakfast of succulent aquatic vegetation. The moose's love of waterways also is a way to keep cool, and protected from insects, in the middle of summer.

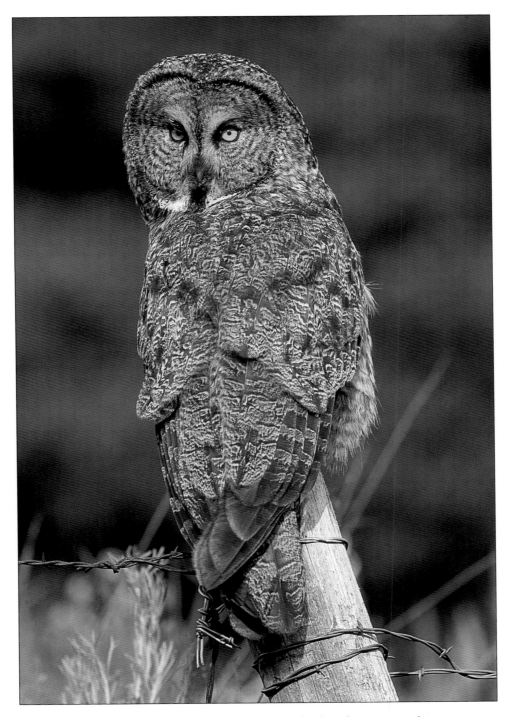

The piercing gaze of a great gray owl is not soon forgotten by those fortunate enough to encounter it. North America's largest owl, standing some thirty-three inches tall, it is one of the few that occasionally hunt during daylight. Although sightings are rare, mixed aspen and evergreen forests are excellent places to search for them.

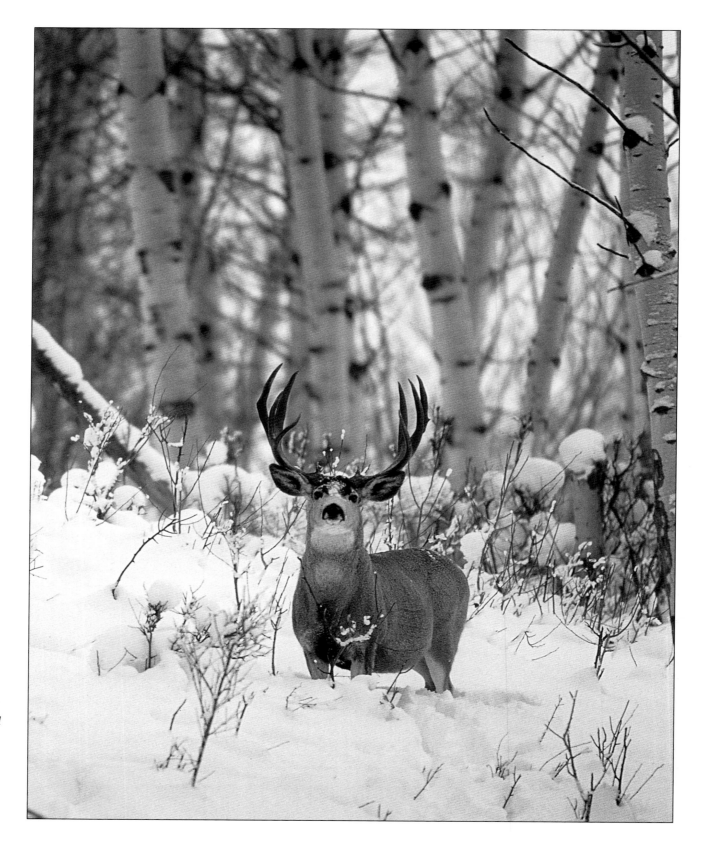

Come January, this mule deer buck in Grand Teton will drop his antlers to conserve energy during the most stressful winter months. In April his new rack will begin to grow.
(RICK KONRAD PHOTO)

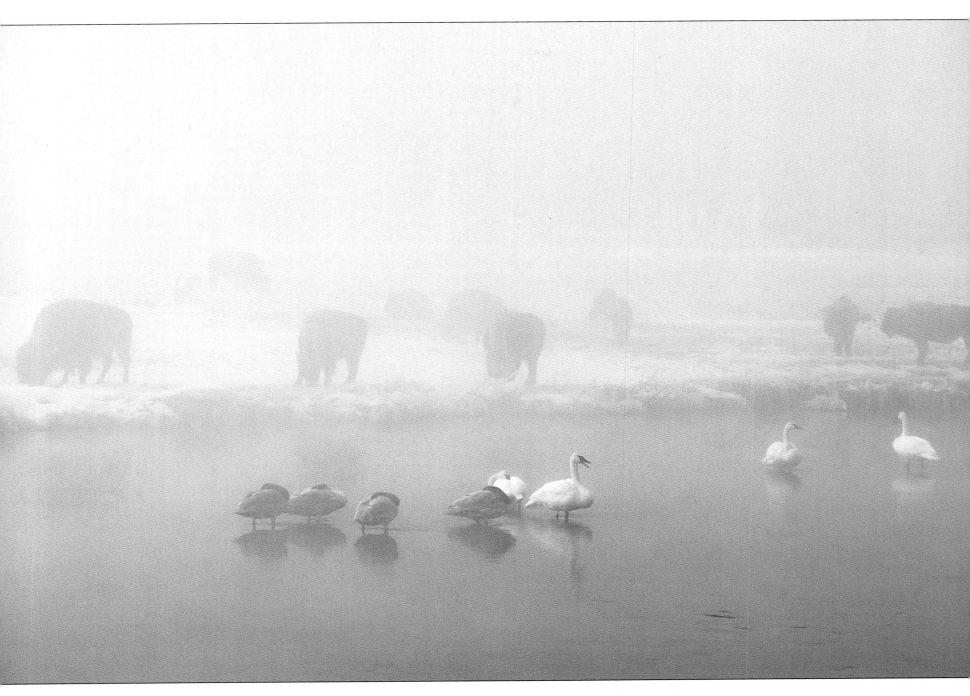

Ghosts of the Firehole River: its ice-free waters provide a winter sanctuary for trumpeter swans and bison, both hunted nearly to extinction and now safe in the Yellowstone region's remote mountain valleys.

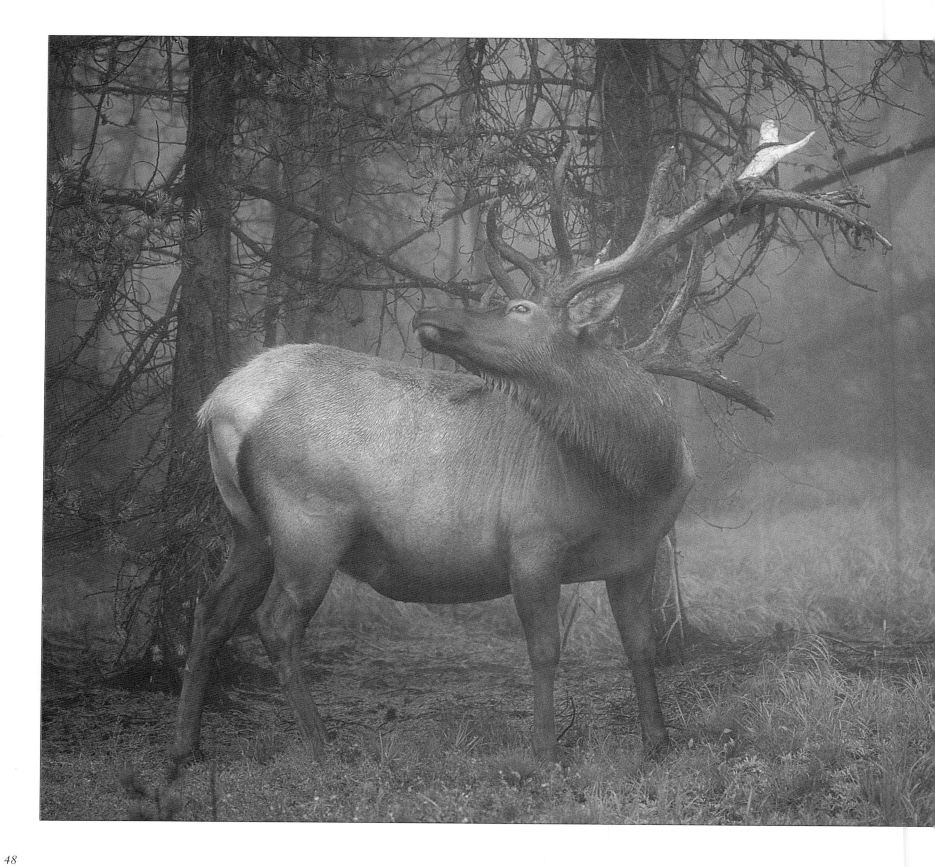

Above: A nesting robin keeps her eggs warm during a late spring snowstorm. Snow can come anytime in the high country.

Left: A bull elk pauses on a mid-August morning to scratch his back while in the midst of shedding antler velvet. Before the fall rut, he will rub his antlers on trees and bushes until they are clean and white.

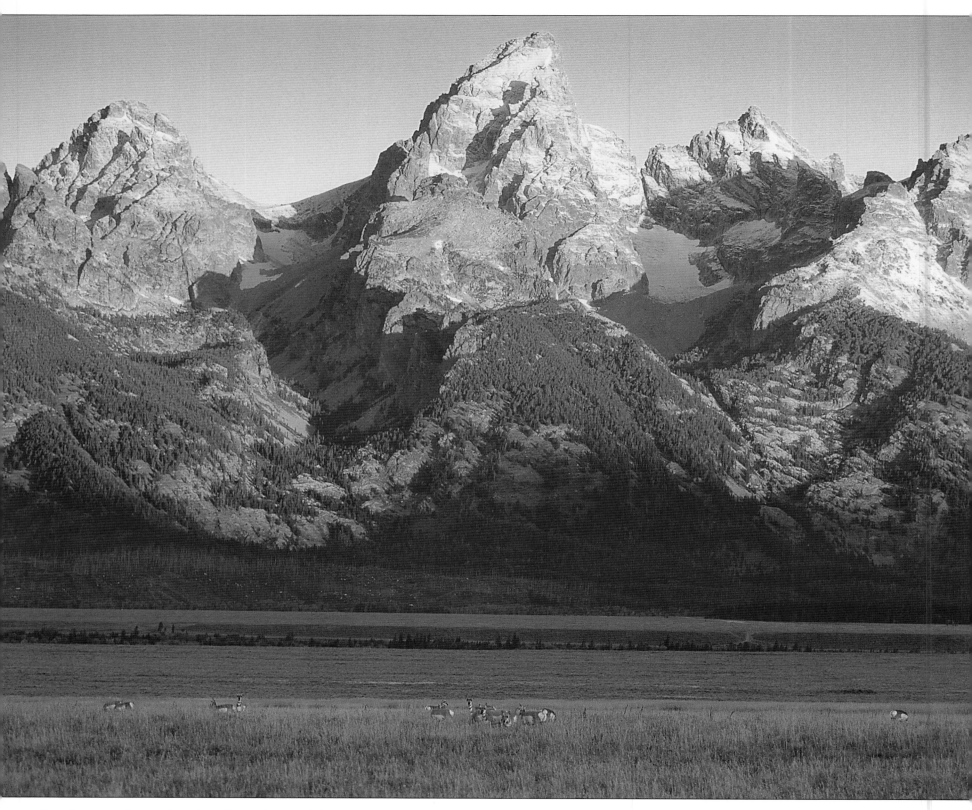

Pronghorn on aptly named Antelope Flats as day's first light hits the Grand Teton. Pronghorns have incredibly powerful vision, a trait that serves them well on the open plains of the west.

50

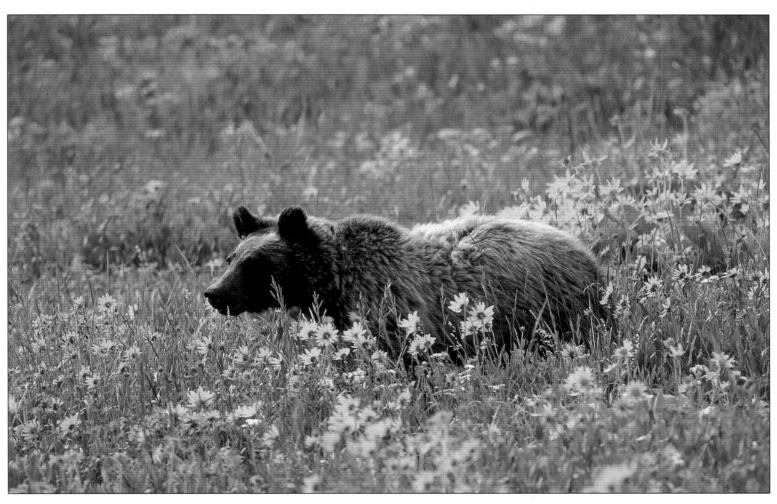

A grizzly bear stops to smell the wildflowers on a beautiful summer day. Yellowstone is one of the last strongholds of the great bear in the continental United States; an estimated 300 to 350 roam the back country of this vast ecosystem. (DAN & CINDY HARTMAN PHOTO)

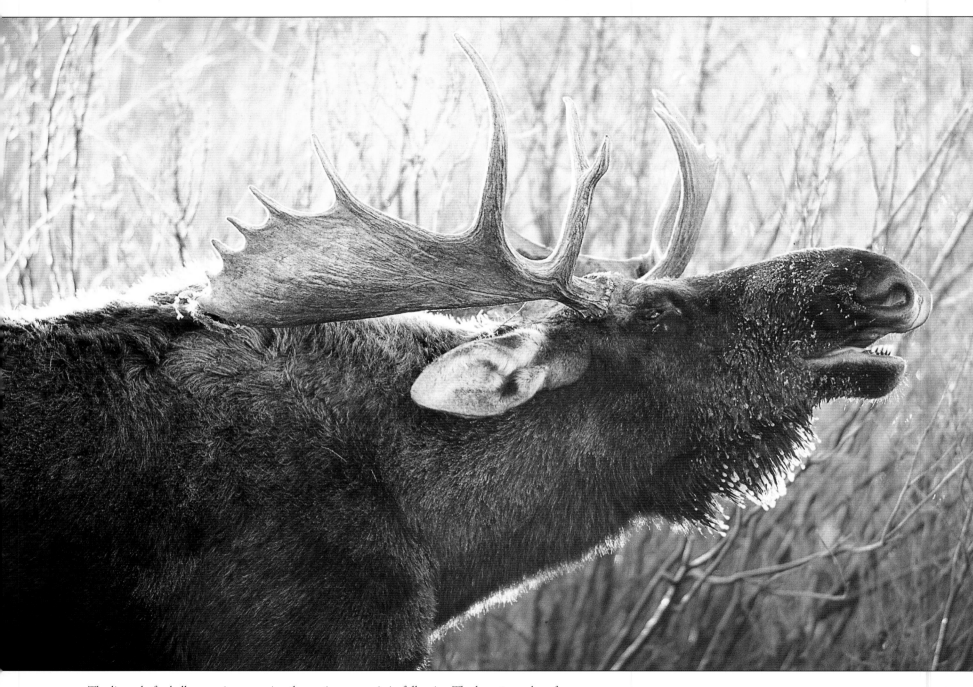

The lip curl of a bull moose is a sure sign the mating season is in full swing. The largest member of the deer family, moose stand six to seven feet tall and may weigh up to 1,200 pounds.

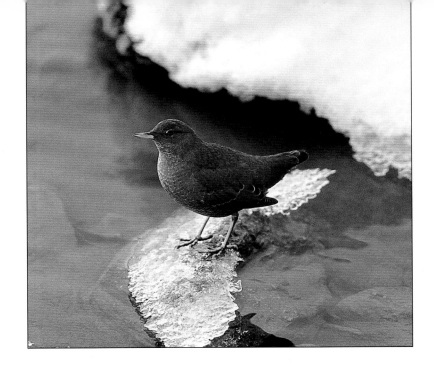

The dipper, or water ouzel, walks under the water of swift-running mountain streams, where it searches for insects, invertebrates, and small fish.

A Canada goose guards her brood of freshly hatched chicks in the National Elk Refuge. Goslings are a common sight throughout the region beginning in early May.

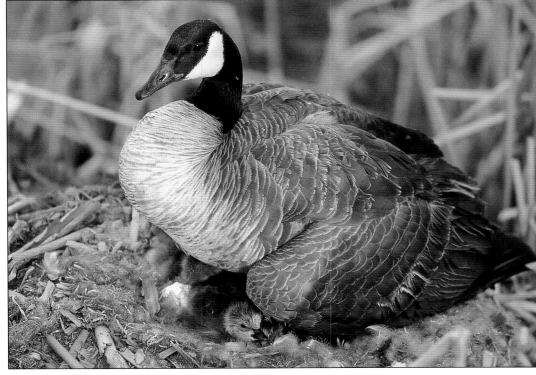

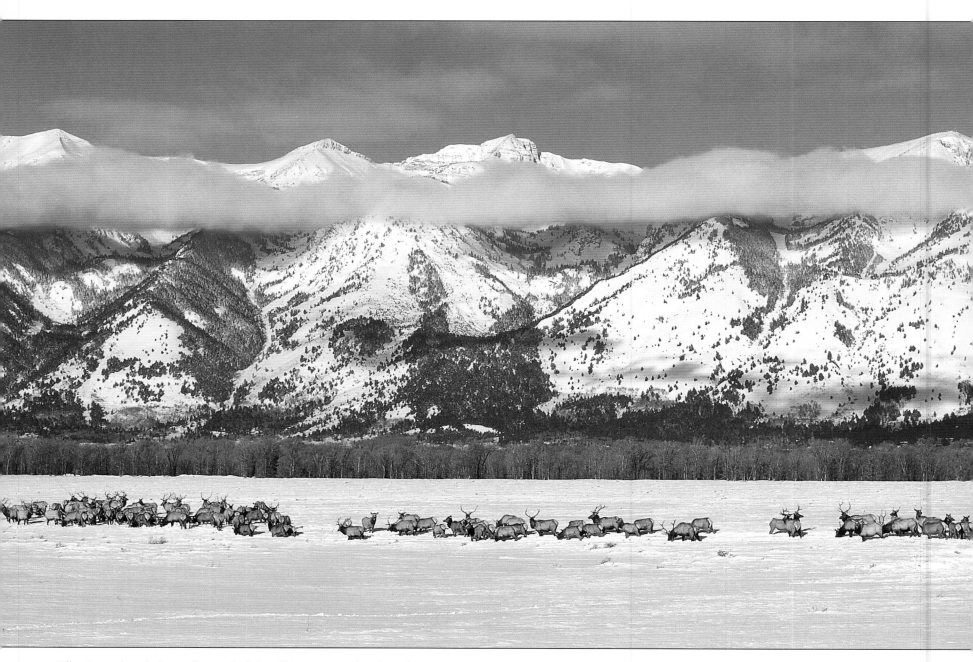

Elk migrate through the southern end of Grand Teton National Park on their way to wintering grounds on the National Elk Refuge. The Yellowstone Ecosystem supports the largest elk herd in North America, with an estimated 90,000 head. From 7,000 to 14,000 spend winter on the refuge.

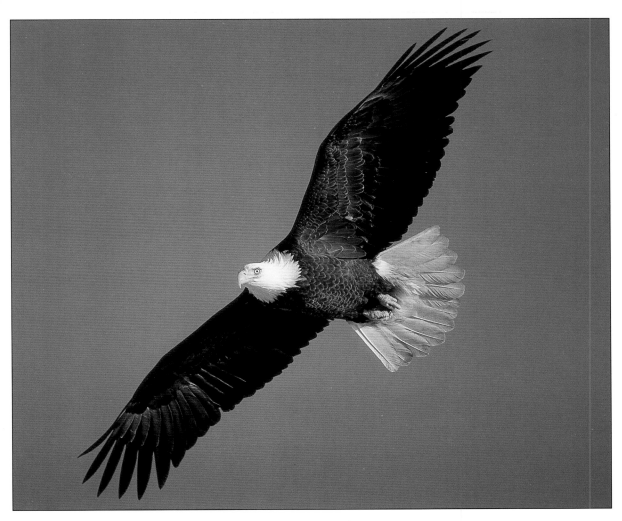

Recently removed from the endangered species list, our national symbol—
the bald eagle—is once again king of the mountain skies.

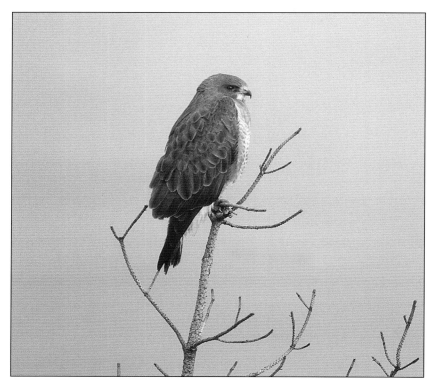

Above: This Swainson's hawk, in the species' light-colored phase, surveys the scene in Hayden Valley, possibly watching for its primary food source, the Uinta ground squirrel.

Right: Yellowstone National Park contains three distinct herds of bison: one that gathers in the Lamar Valley, another in the Pelican Valley, and a third that uses the Hayden (here, at Trout Creek) and Firehole valleys.

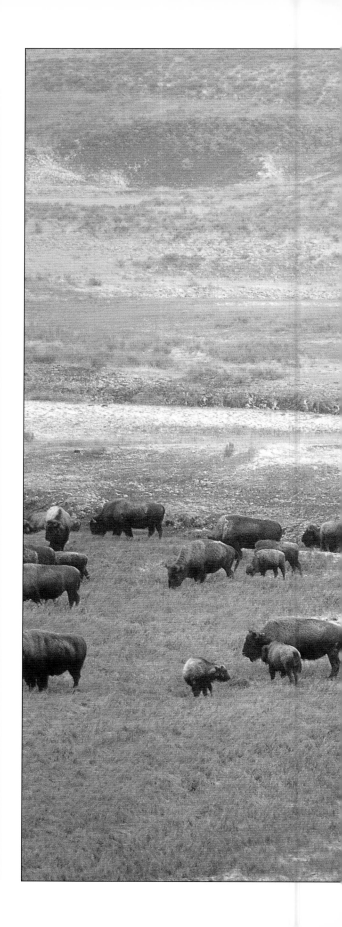

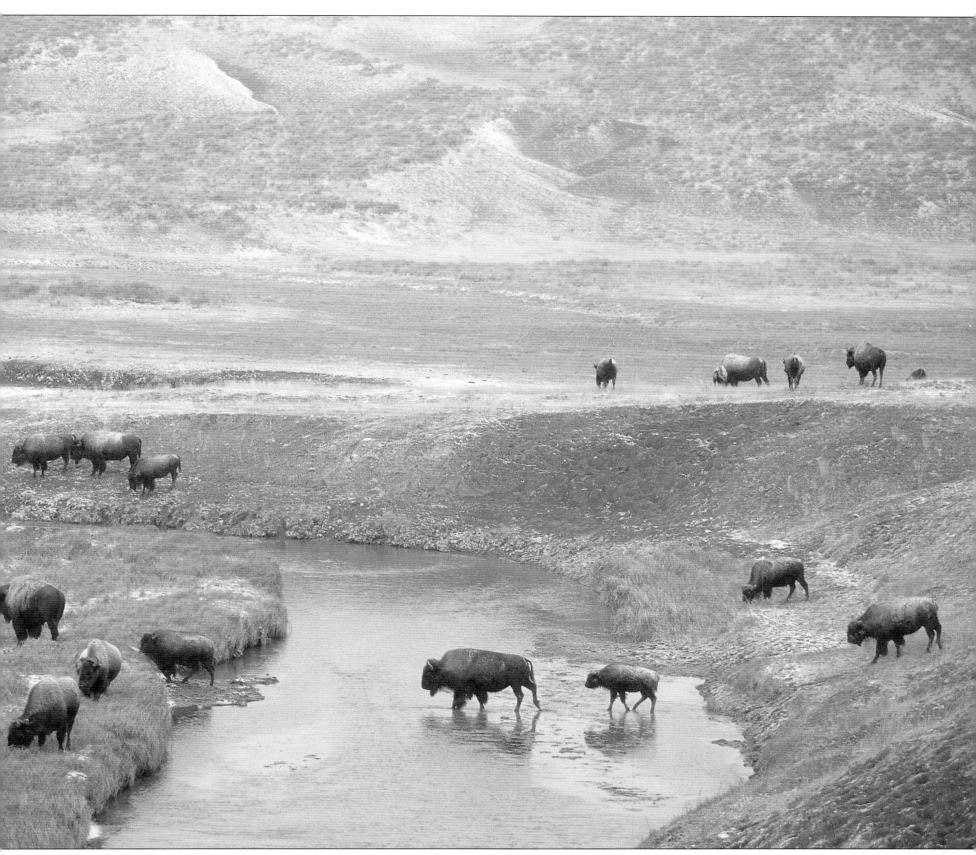

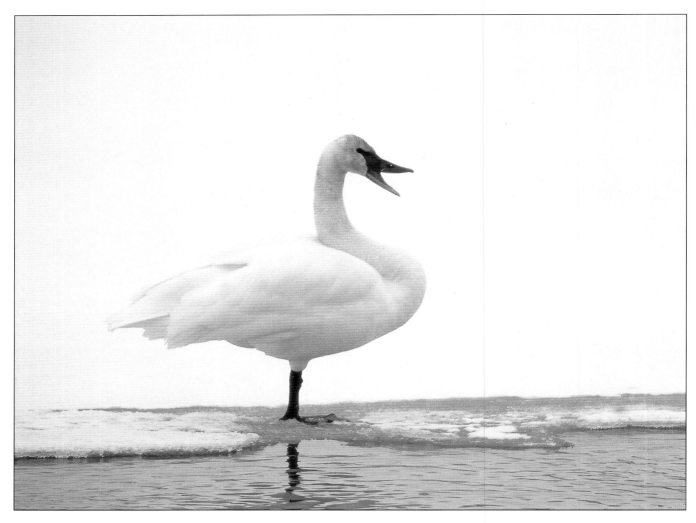

Above: A swan the color of winter calls out to its mate. Many trumpeters arrive at the National Elk Refuge in November and stay until the winter freeze begins.

Facing page: The loud crack of clashing horns, occasionally heard down in Gardner Canyon, rings out in November's still air at the onset of the bighorn sheep rut, when rams duel for supremacy.

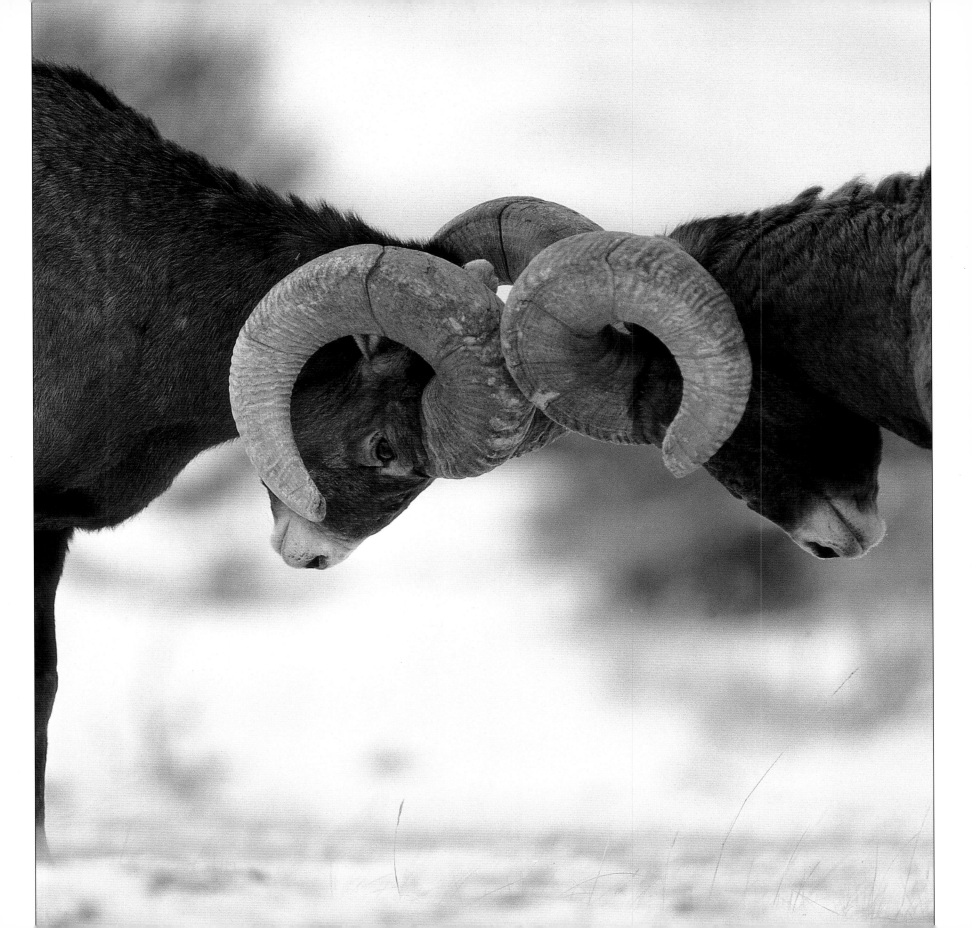

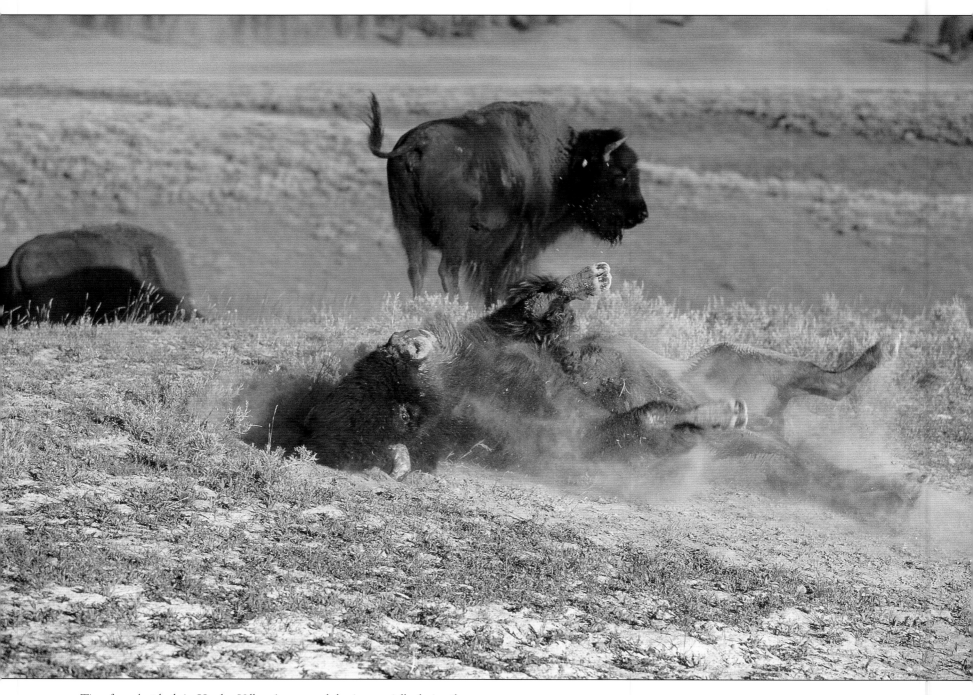

Time for a dust bath in Hayden Valley. A common behavior especially during the bison rut, it gives a good scratch where no trees are available, helping rid the animals of bothersome insects.

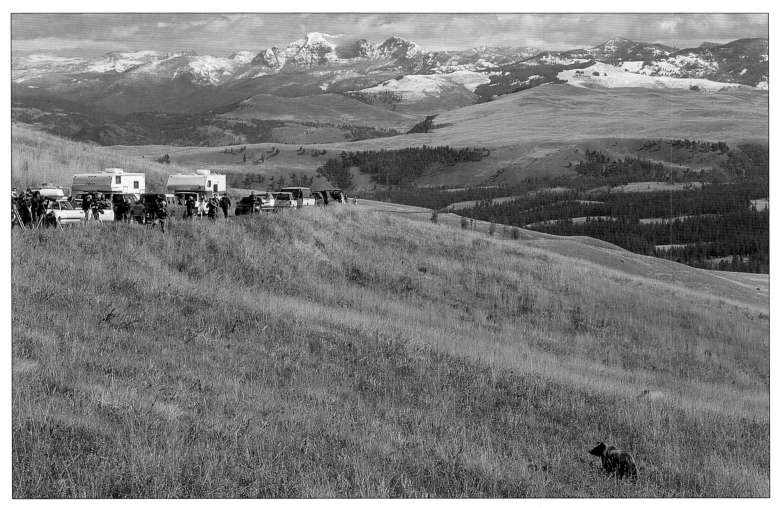

A "bear jam" stops traffic along the northern slope of Mount Washburn. Yellowstone National Park is one of the few places people can view the great bears roaming free. Their presence helps make Yellowstone the wildest place in the continental U.S., a place that represents the true meaning of wilderness.

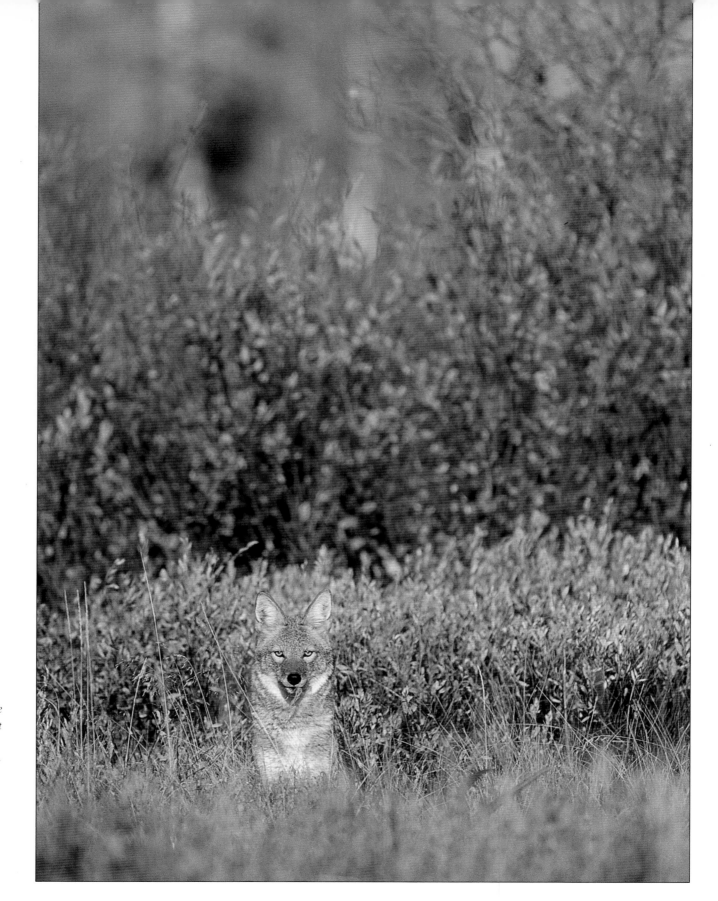

Coyotes, wily and very adaptable opportunists, can be found living almost anywhere in the Yellowstone ecosystem. As autumn develops, his coat will thicken for winter warmth.

Black-tailed prairie dogs are not found in either Yellowstone or Grand Teton, but can be seen on the plains north and east of Yellowstone. This fellow's smaller, sleeker cousin, the Uinta ground squirrel, is abundant inside the parks, and a main food source for raptors, coyotes, badgers, wolves, and grizzlies.

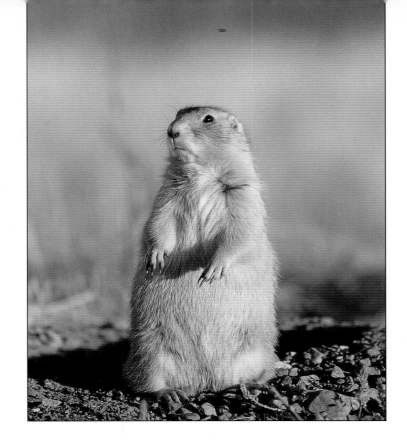

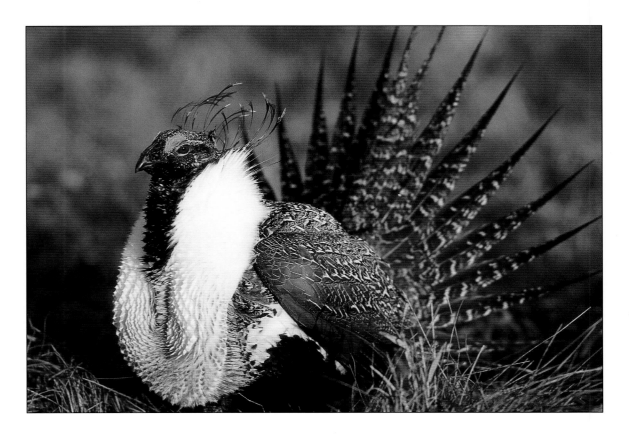

Male sage grouse in spring courtship display, fluffing his feathers and making a strange blooping noise using air sacs on his chest. The "booming" at dawn and dusk is to impress the females.

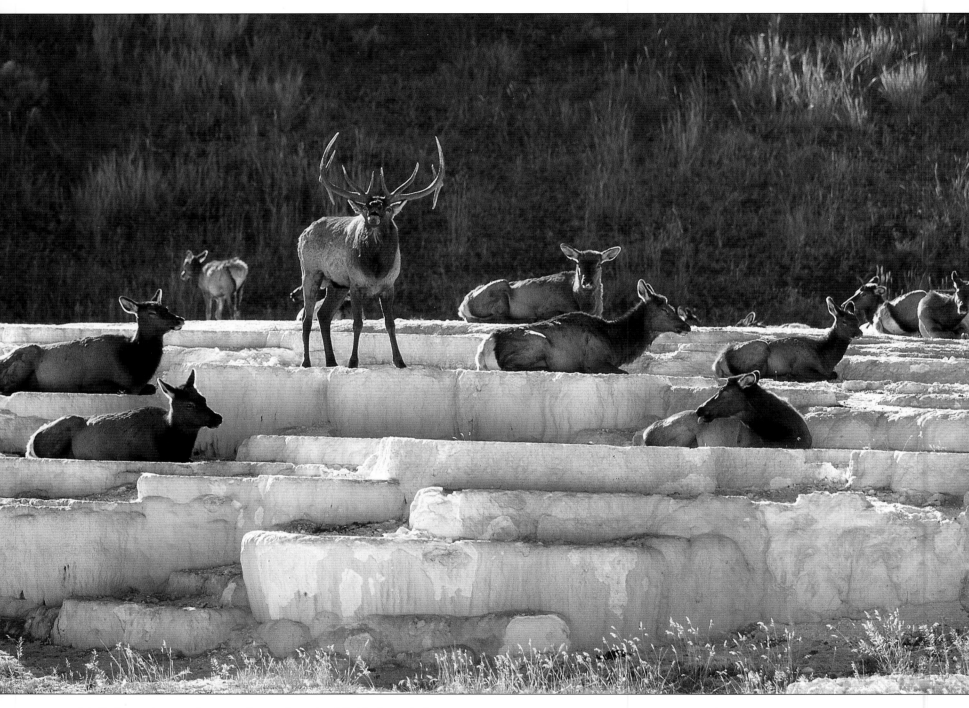

*A bull elk sounds a warning at another nearby male while his charges look
on from their warm seats on the terraces of Mammoth Hot Springs.*

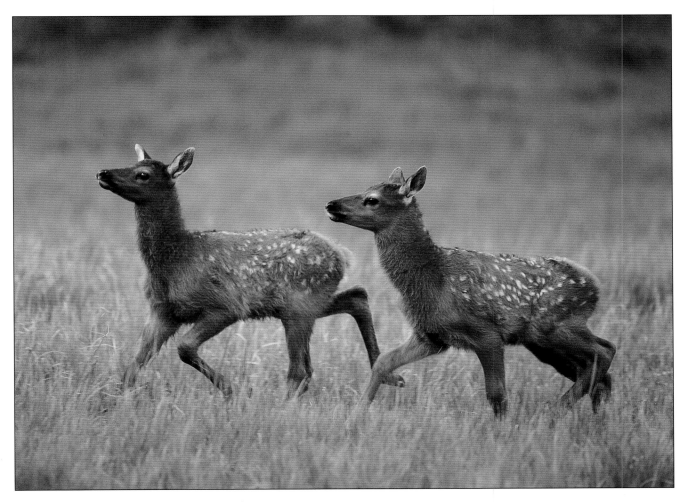

Spring is a wonderful time to witness the explosion of life in the high country, like these twin elk calves frolicking in Gibbon River meadows in the center of Yellowstone Park.

Left: One of the first birds to arrive each spring, robins signify that winter is finally ending.

Facing page: This bull moose along the Lewis River has antlers encased in velvet, skin filled with capillaries that bring blood to his growing rack. He will lose his antlers in late December or January, and in April they will begin to grow once more.

Sage grouse play out their mating rituals below the peaks of the Tetons. From mid-April to mid-May they gather at dawn on their ancestral courtship grounds, called leks, to perform their noisy displays.

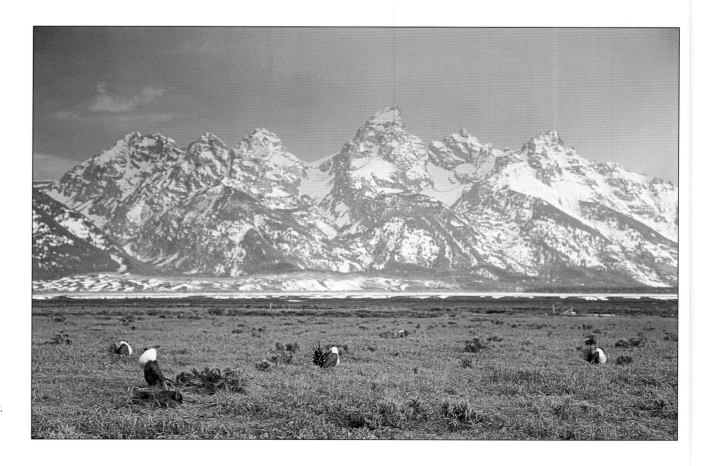

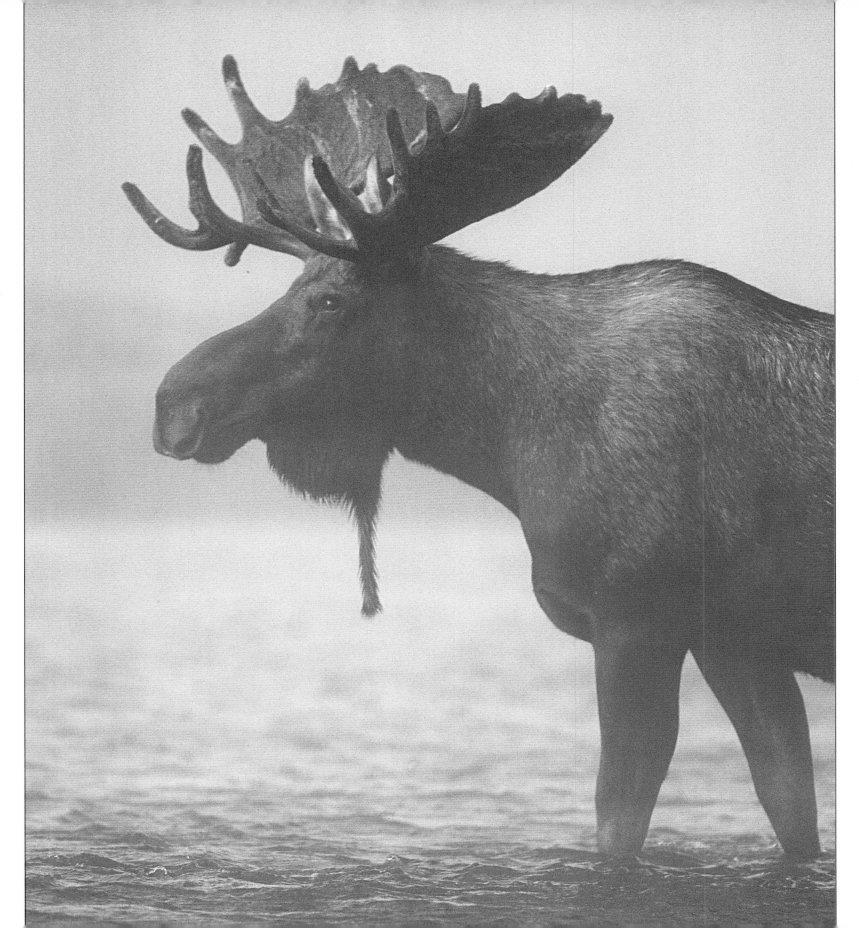

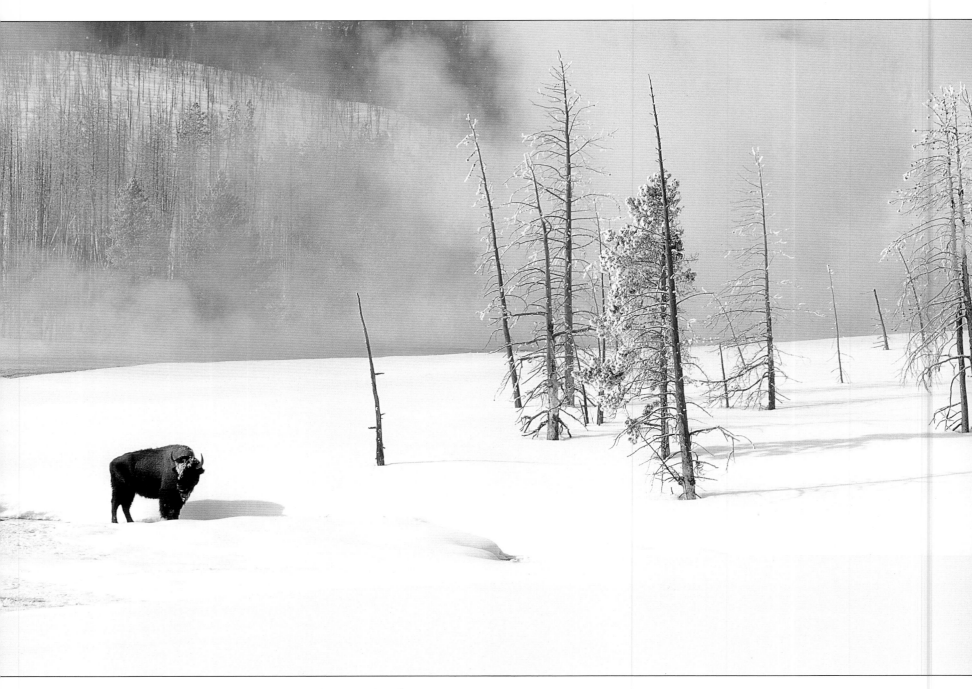

Bison have learned to utilize Yellowstone's thermal features, such as Upper Geyser Basin seen here, to make winter grazing and travel less taxing.

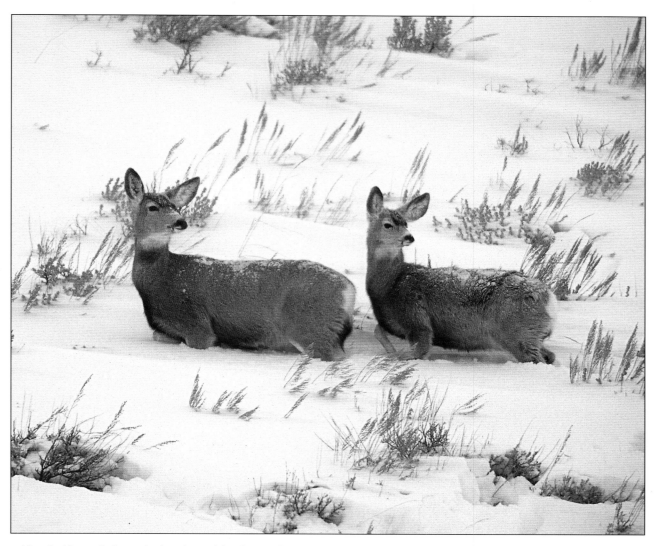

After the blizzard, this mule deer doe and her fawn will seek out slopes of windblown buttes in their attempt to make it through a Jackson Hole winter.

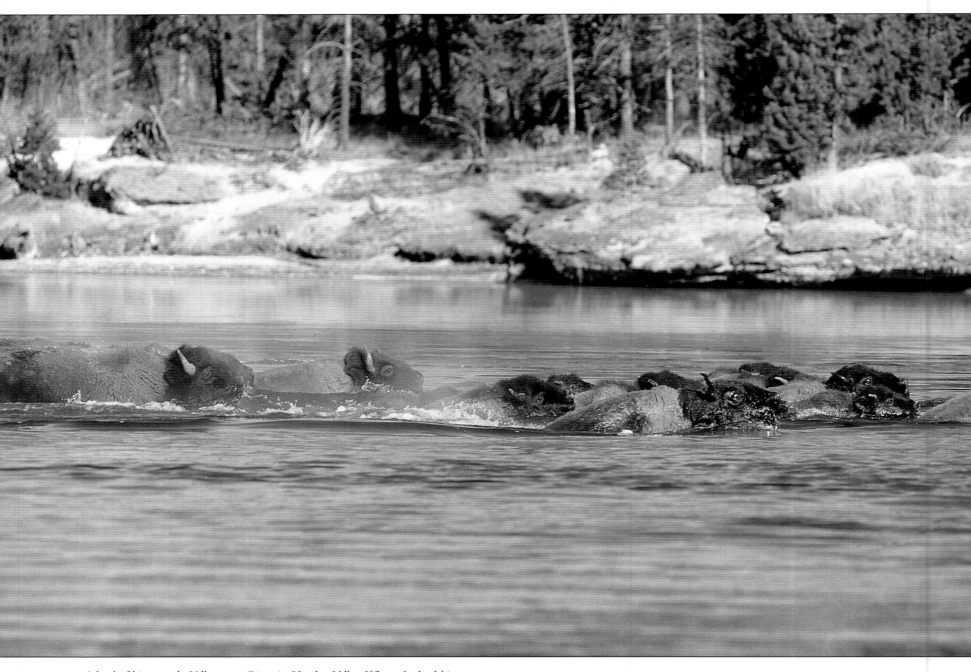

A herd of bison at the Yellowstone River in Hayden Valley. Where the lead bison goes the rest of the herd is sure to follow. It can sometimes take hours for the entire herd to pass.

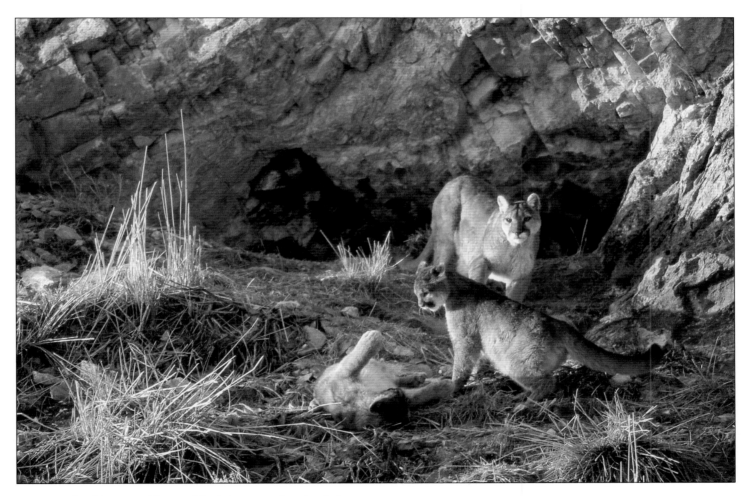

Mountain lion kittens roughhouse while their concerned mother looks on. This scene took place on the National Wildlife Refuge one March afternoon in 1999. In what was most likely a once in a lifetime opportunity for human watchers, this family of cougars, including the mother and three kittens, spent almost forty-five days hunting and resting on the refuge. Normally shy and nocturnal in nature, the mountain lion is a valuable predator in the rugged terrain of the ecosystem.

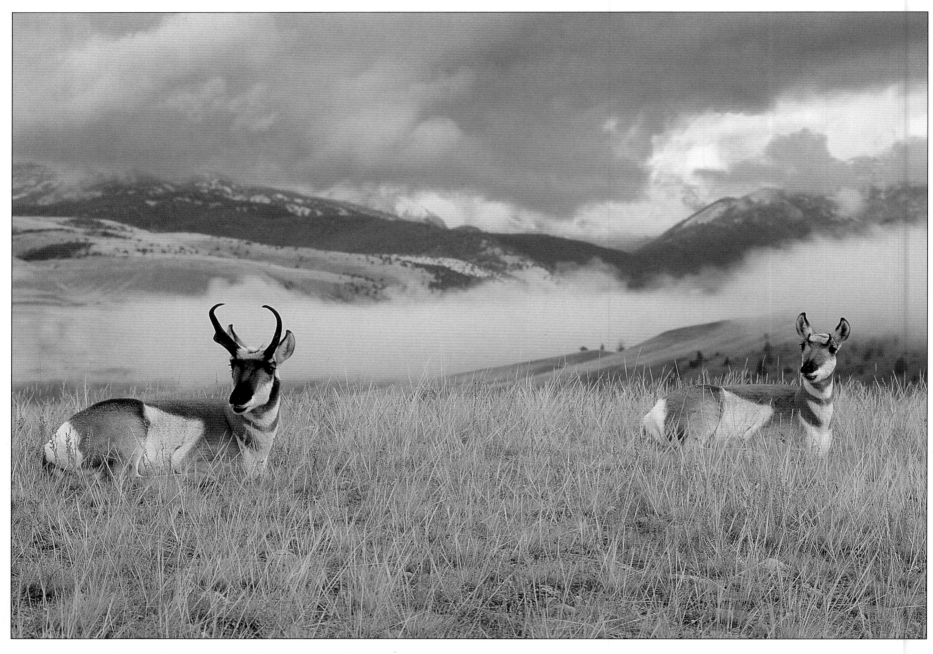

A pronghorn buck and doe take a break on the slopes north of Mammoth Hot Springs. The pronghorn is an animal of the open plains and in Yellowstone is most commonly found from Roosevelt to Lamar Valley and from Mammoth north to Gardiner, Montana.

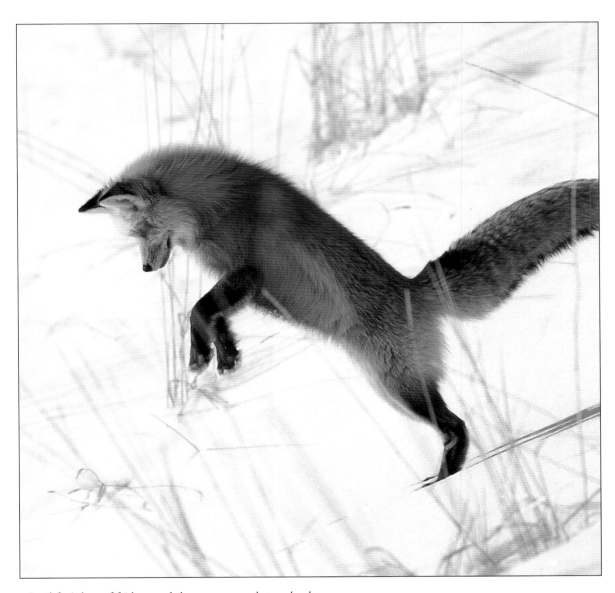

A red fox's leap of faith toward the mouse or pocket gopher he senses below the snow. Known locally as mountain foxes, these light, yellowish creatures can be seen in the Absaroka Range in Yellowstone's north.
(DAN & CINDY HARTMAN PHOTO)

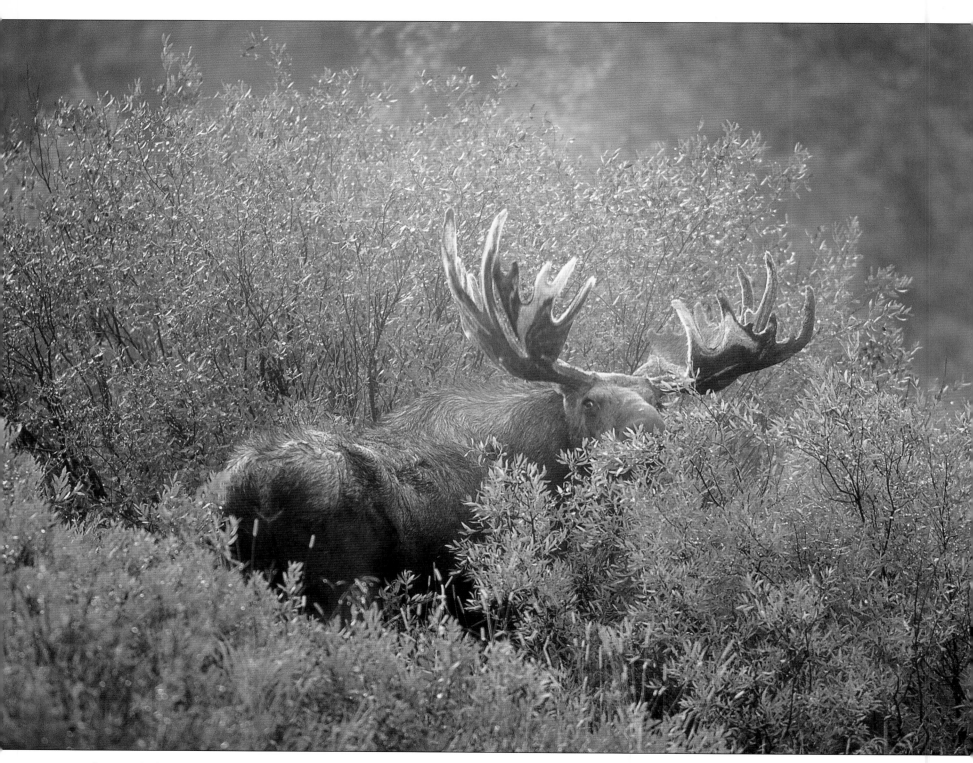

*Willows are the bull moose's favorite year-round food; he will
eat the leaves in summer, and twigs and buds in winter.*

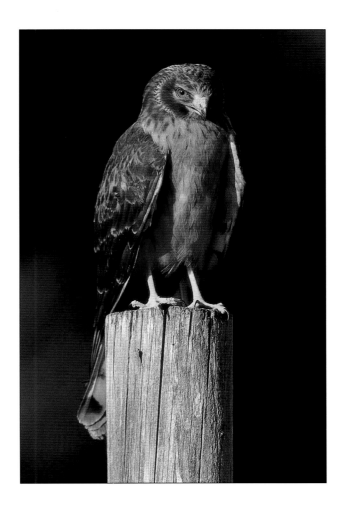

An immature northern harrier, a type of hawk that is a summer resident of the ecosystem and can often be seen hovering or cruising in search of prey over meadows or marshy areas.

A tenacious predator with a low center of gravity, the badger (seen here in the Lamar Valley) is an animal built for digging. Its main food sources are ground squirrels, gophers, mice, and rattlesnakes.

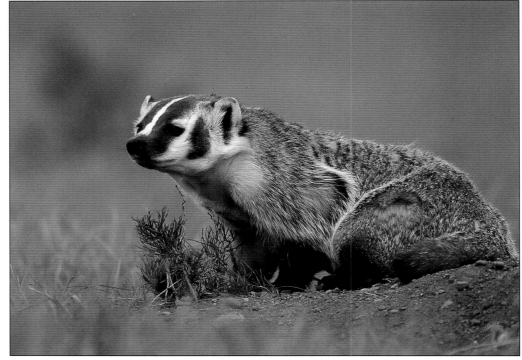

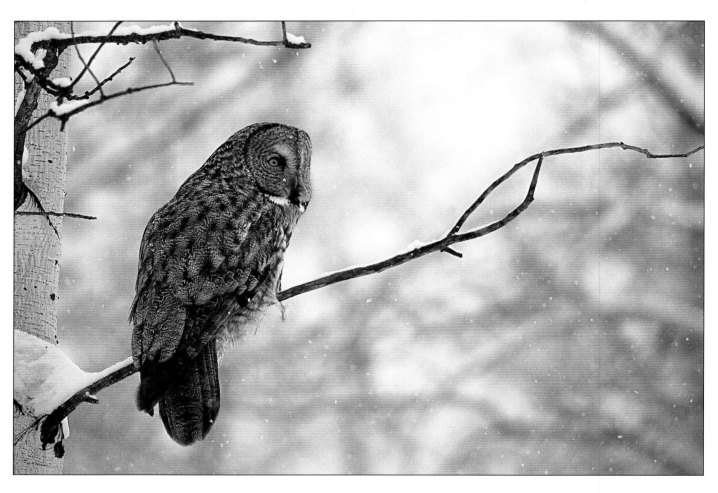

Above: It may move from its nesting territory in search of better winter hunting grounds, but the great gray owl is one of the few that stay close to summer range throughout the snowy alpine winter.

Right: Although their numbers in the Lamar Valley (seen here) have dropped since the return of wolves to the area, coyotes are still the most common predators seen in the parks.

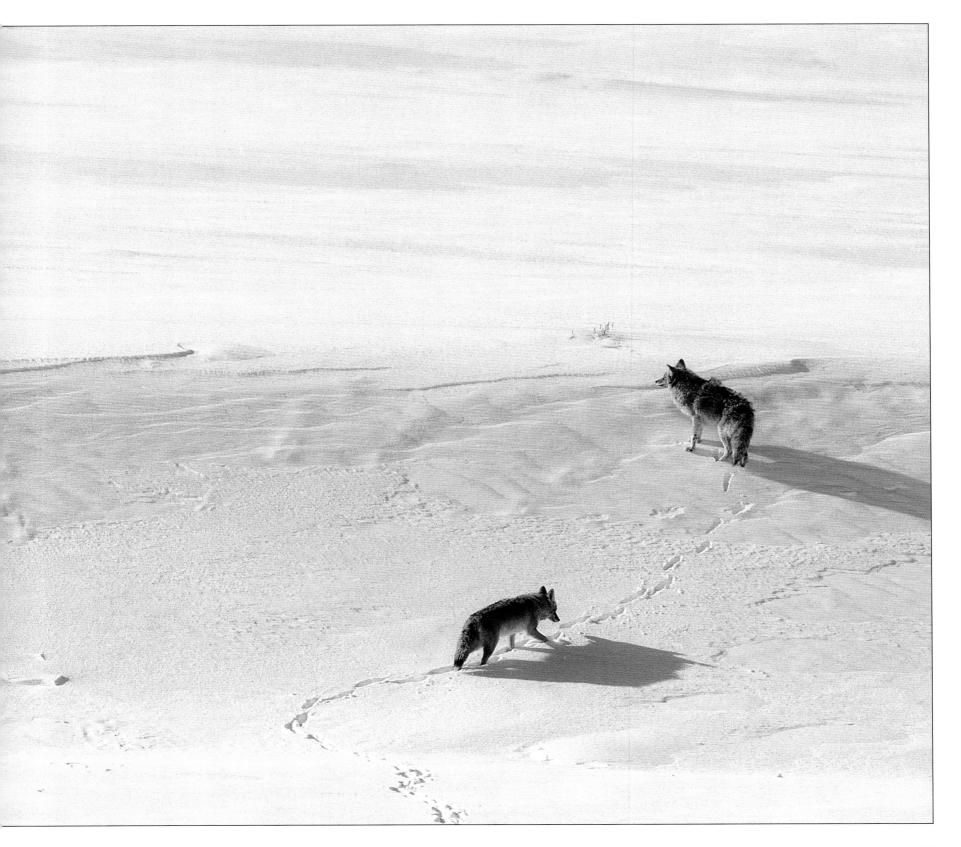

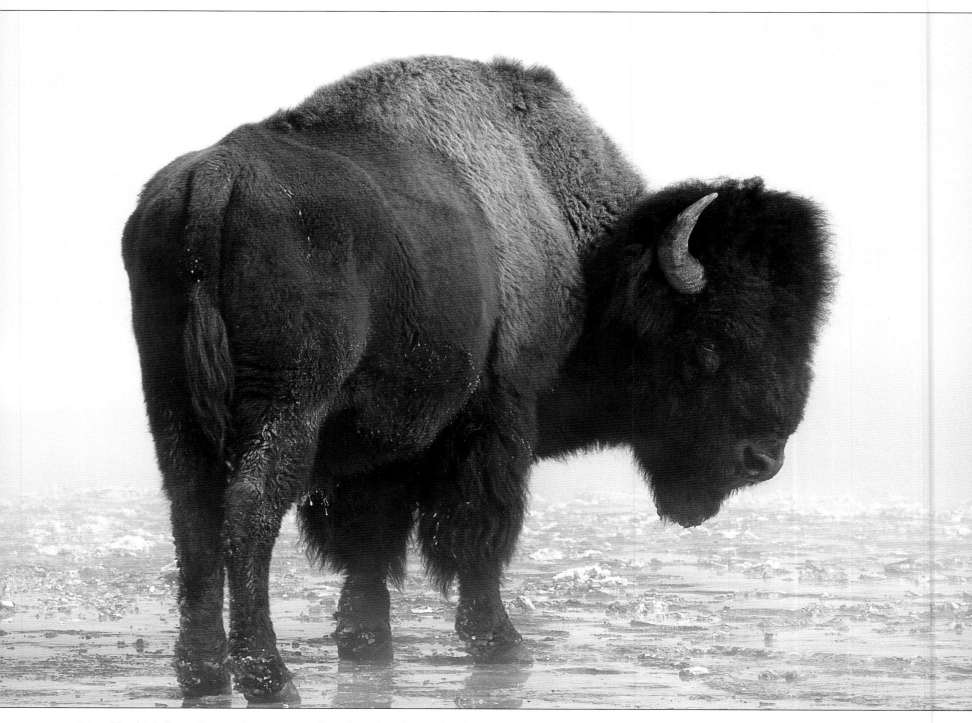

Bison, like this bull, are the most dangerous animals in the park and not to be taken lightly. Each year several visitors are gored when they end up too close to bison.

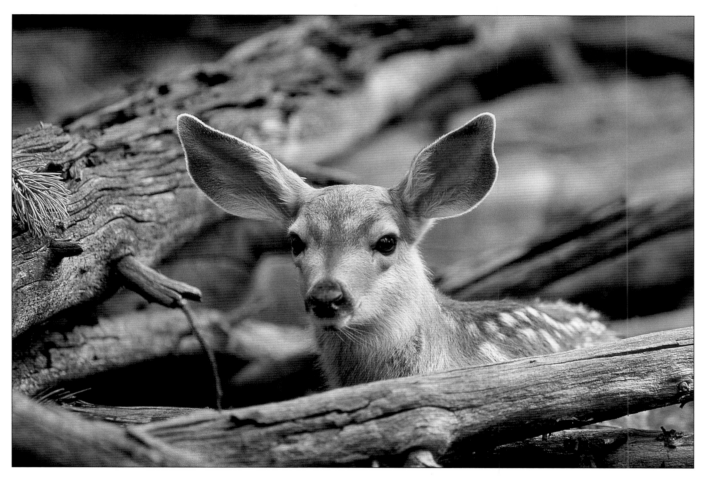

*Using camouflage (here, amid downed timber of a lodgepole forest)
and its lack of scent, this mule deer fawn will spend much of its
first month out of sight.*

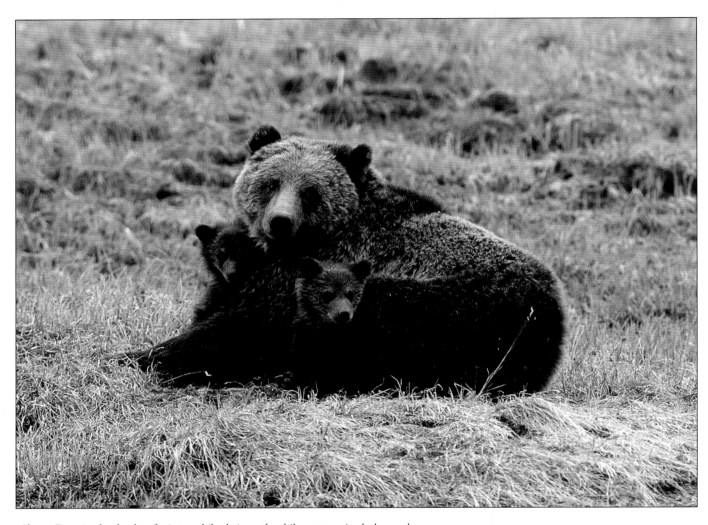

Above: Born in the depths of winter while their mother hibernates, grizzly bear cubs stay with her for the first two and a half years of their lives. In that time she will teach them all they need to know about being a grizzly. If lucky they may live to the ripe old age of thirty-five. (DAN & CINDY HARTMAN)

Facing page: A magpie serves as "hairdresser" for a fluffed up cow elk, helping remove insects from the animal's fur. This symbiotic, or mutually beneficial, behavior keeps both animals looking their best.

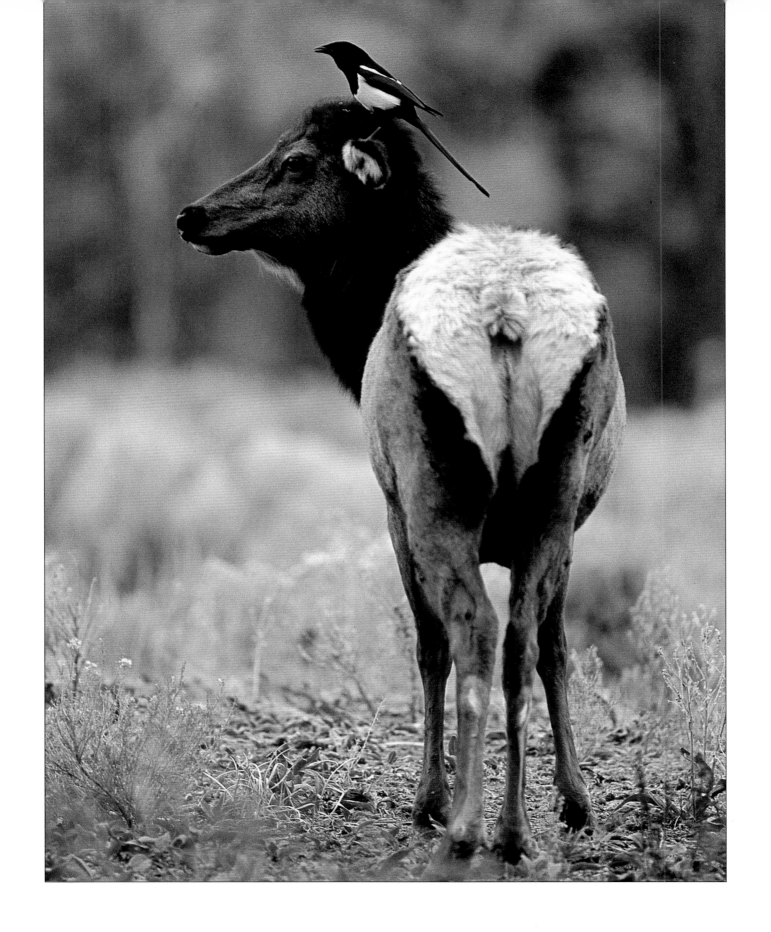

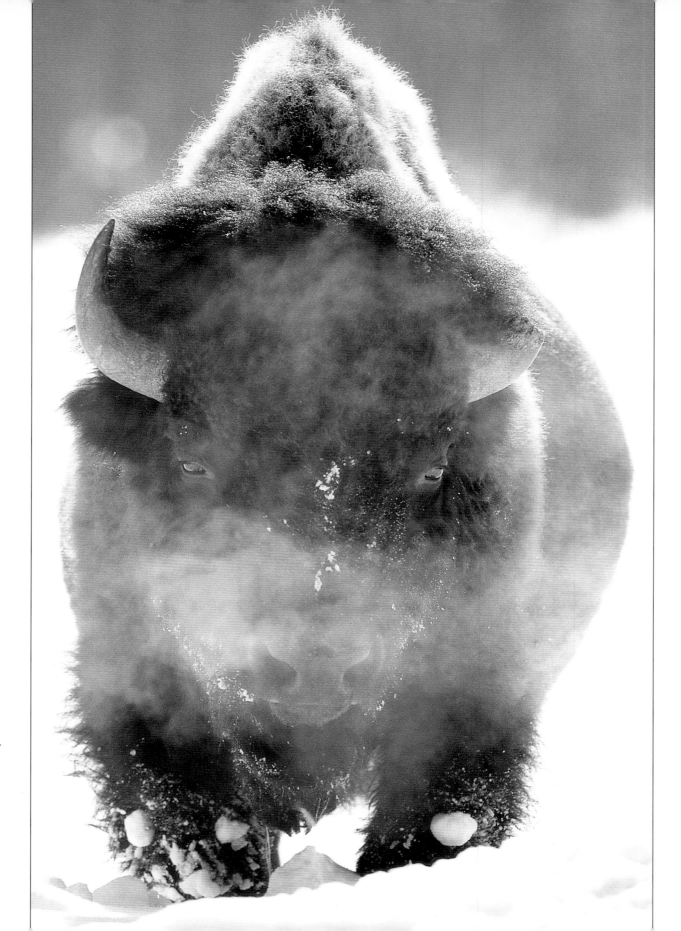

Bison, like this Lamar Valley bull, use their massive heads as snow-plows to reach the grasses beneath deep winter snow.

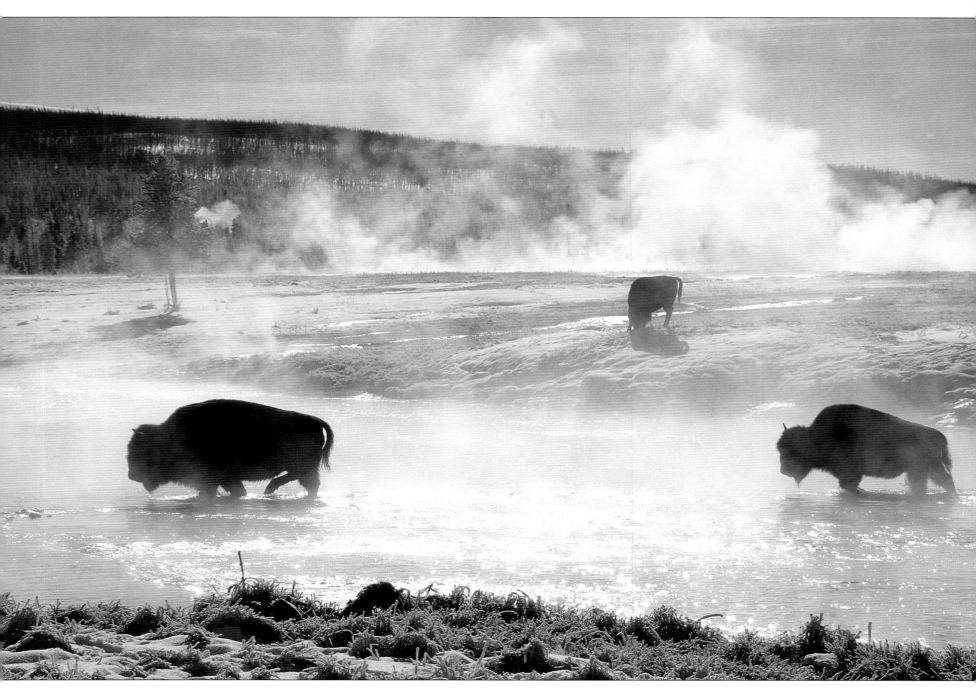

Covering all possible surfaces on clear, cold nights, hoarfrost likes this on the Firehole River helps transform Yellowstone into a winter wonderland.

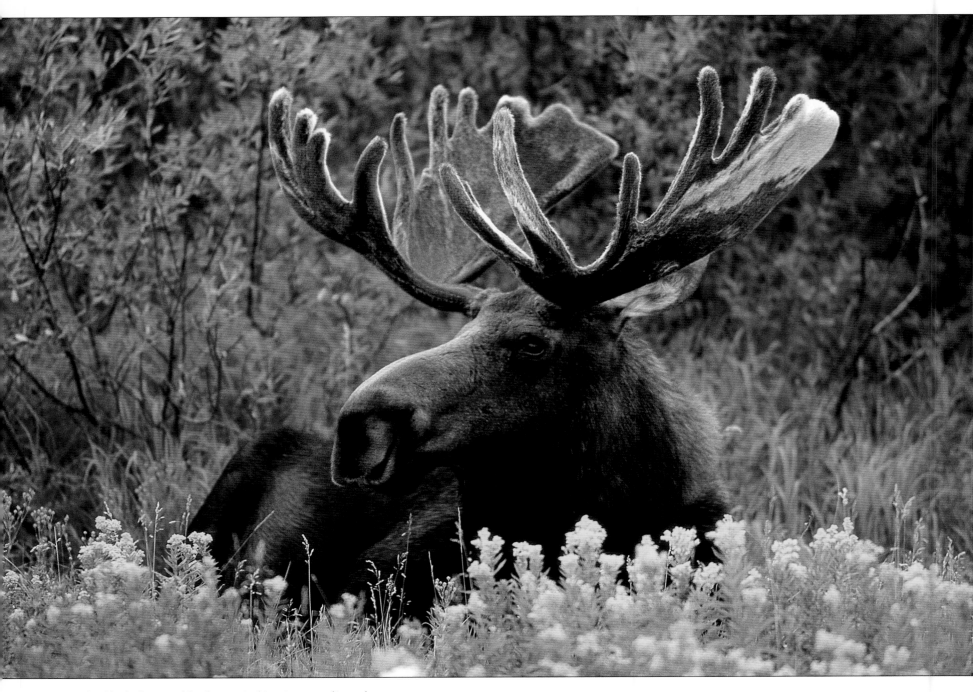

A healthy bull moose, like this one in his prime, may live to be twenty or twenty-five years of age.

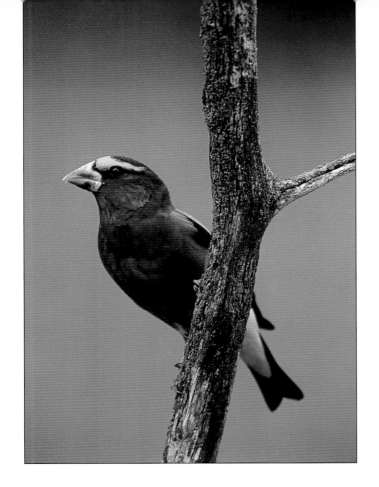

Evening grosbeaks are vertical migrants, utilizing the higher conifer forests in summer and spending the winter at backyard feeders down below.

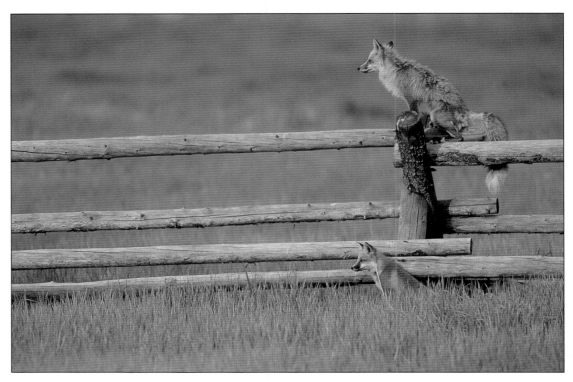

A buckrail fence makes a nice lookout for a red fox and her kit. Foxes are common but rarely seen on the ranch-lands surrounding the parks.

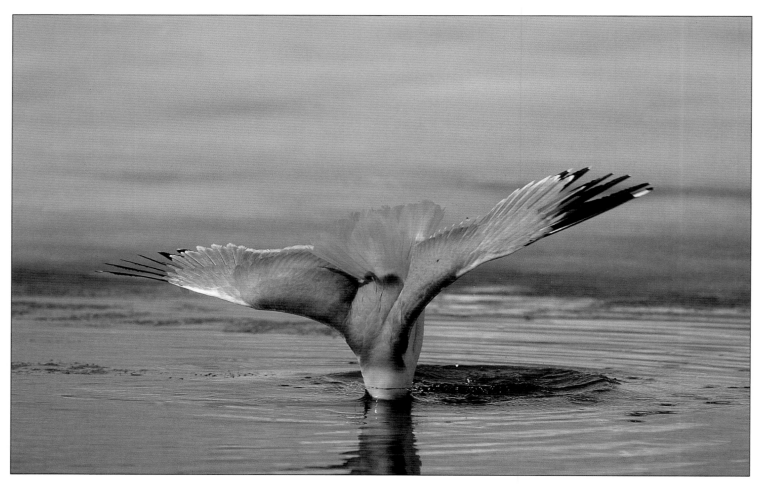

Most likely fishing for minnows, this California gull seems out of place on still frozen Yellowstone Lake. Arriving in early spring before full thaw, a small population of gulls spends the summer here. Come October, they head south to wintering grounds on the Great Salt Lake.

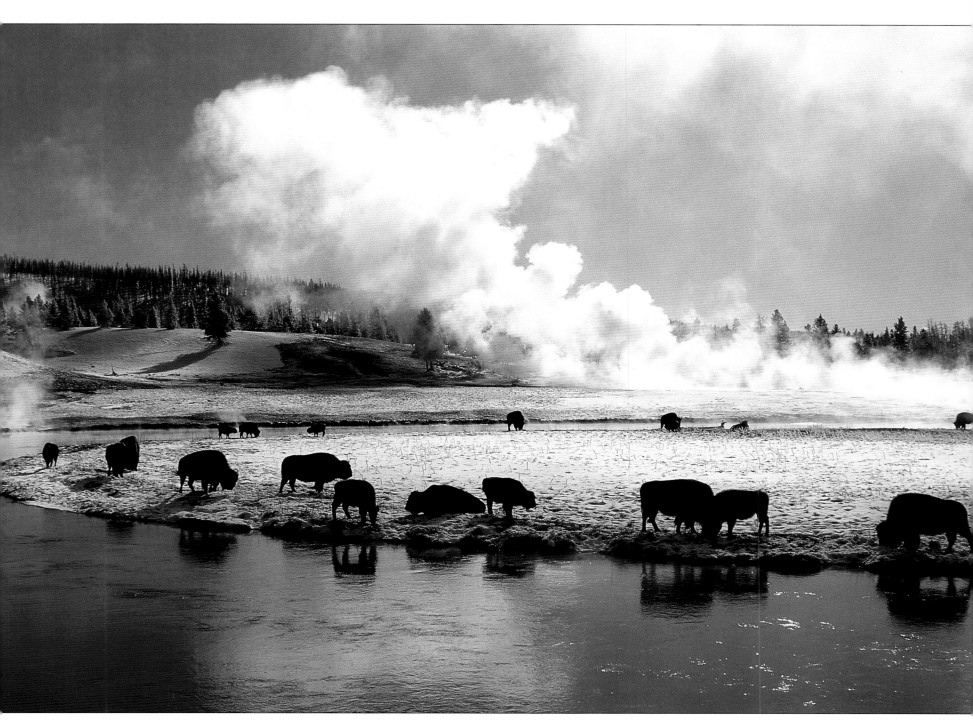

The Firehole River is an excellent place to view wildlife in all seasons, but it is exceptionally rewarding in winter.

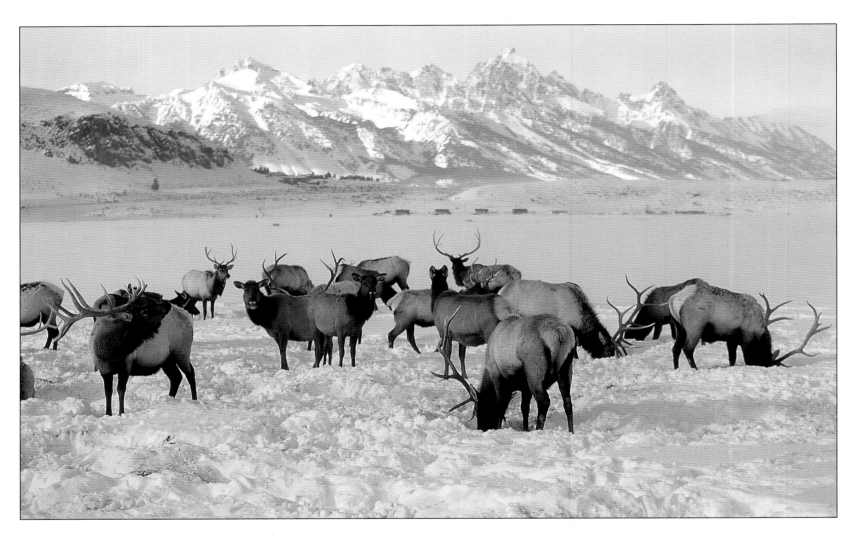

In late October, large herds of elk begin arriving in the Teton area. In April, they migrate north or east into the Gros Ventre Mountains, the Tetons, and southern Yellowstone.

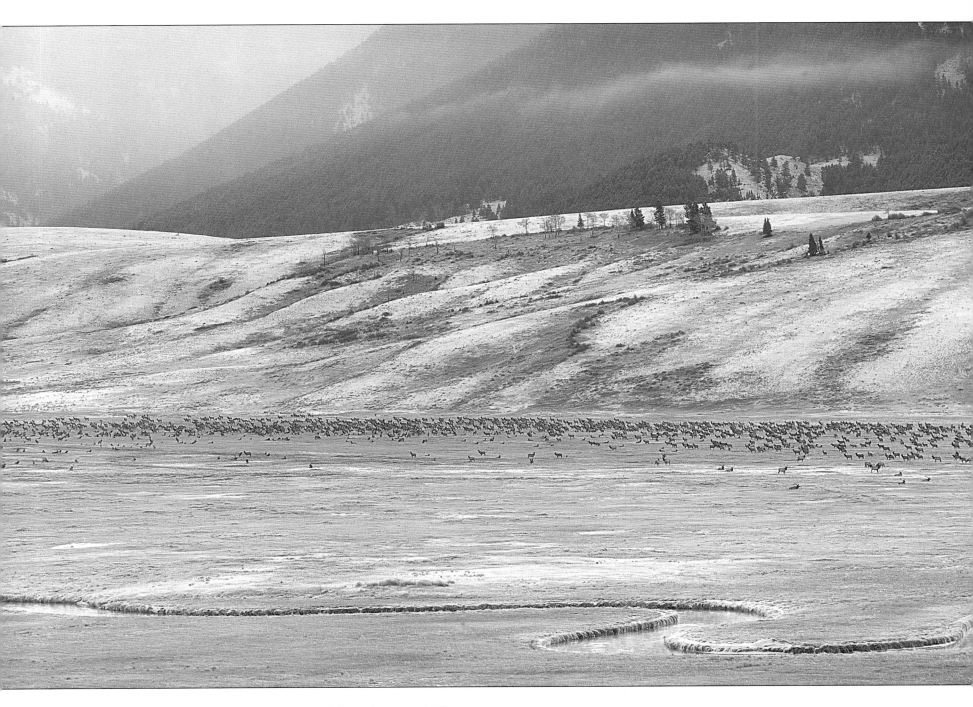

The distant howl of wolves captures the attention of elk on the National Elk Refuge. Three separate wolf packs have discovered the refuge's bounty, and may spend part of the winter exploring its possibilities.

Meriwether Lewis recorded and named the "Clark's nutcracker" for his co-captain on the Lewis and Clark Expedition, and for its feeding habit of extracting seeds from pine cones with its long sharp bill.

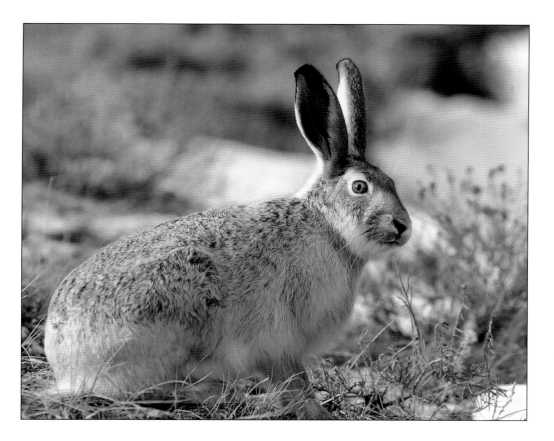

A lowland cousin to the higher-altitude snowshoe hare, the whitetail jackrabbit can be found on the sagebrush flats surrounding the parks. When pursued by a predator, the whitetail can reach speeds of forty miles per hour and bound some fifteen feet in one leap.

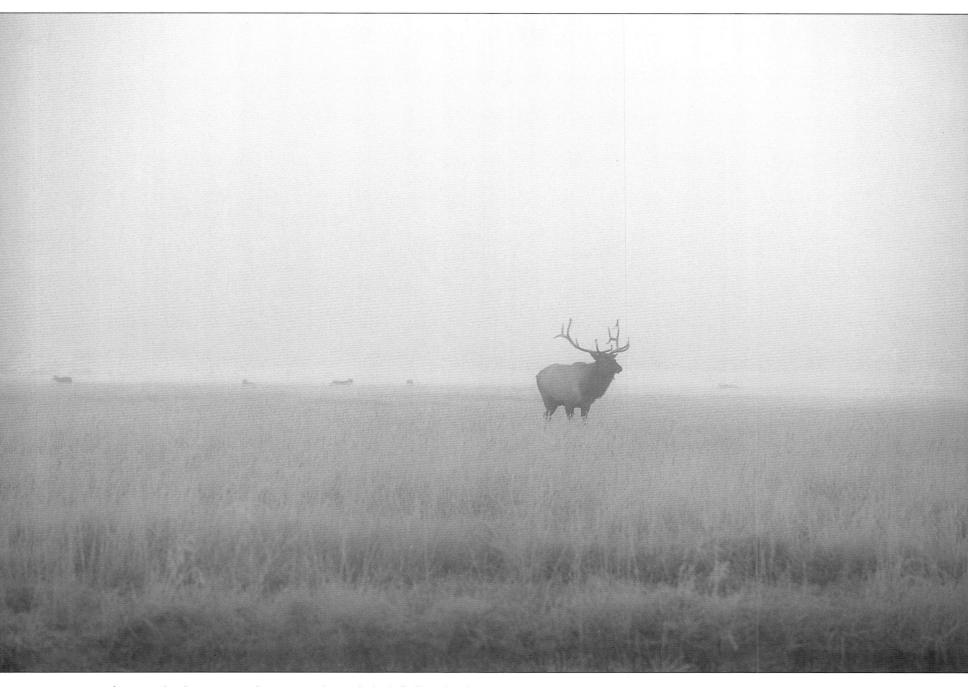

One frosty October dawn, as one other person and I watched a bull elk tending his harem along the Gibbon River, the fog lifted slightly and the shapes of five wolves appeared. The frenzied bull quickly formed his cows into a tight band, but the wolves—cover blown—simply disappeared into the tall grass. The possibility of such wildlife encounters makes Yellowstone an extraordinary place.

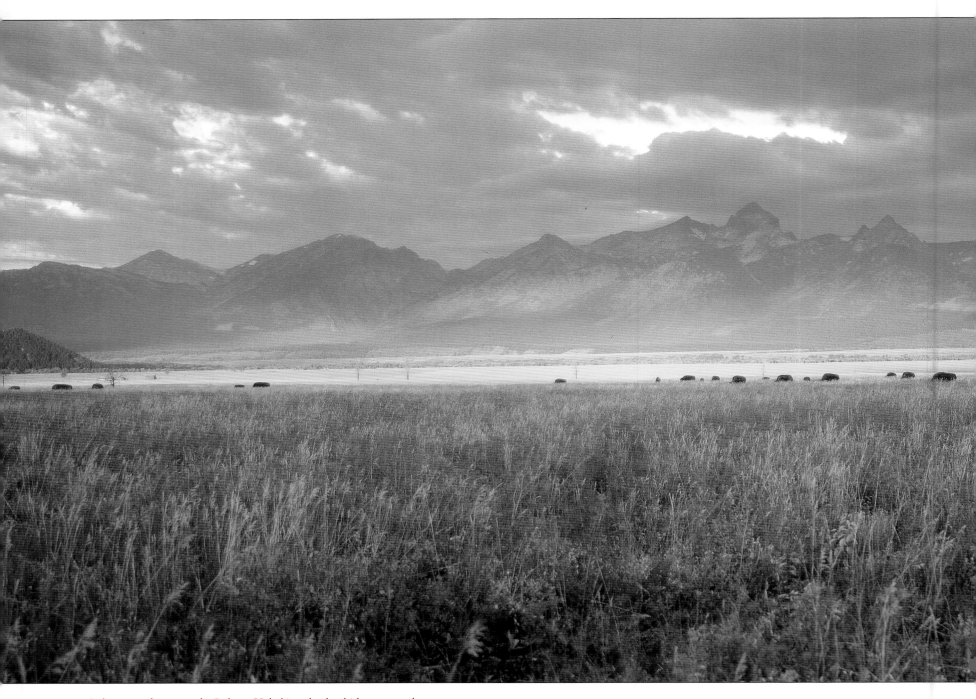

At home on the range: the Jackson Hole bison herd, which now numbers some 400 animals, spends its summers near Moran, autumns on Antelope Flats, and winters on the north end of the Elk Refuge.

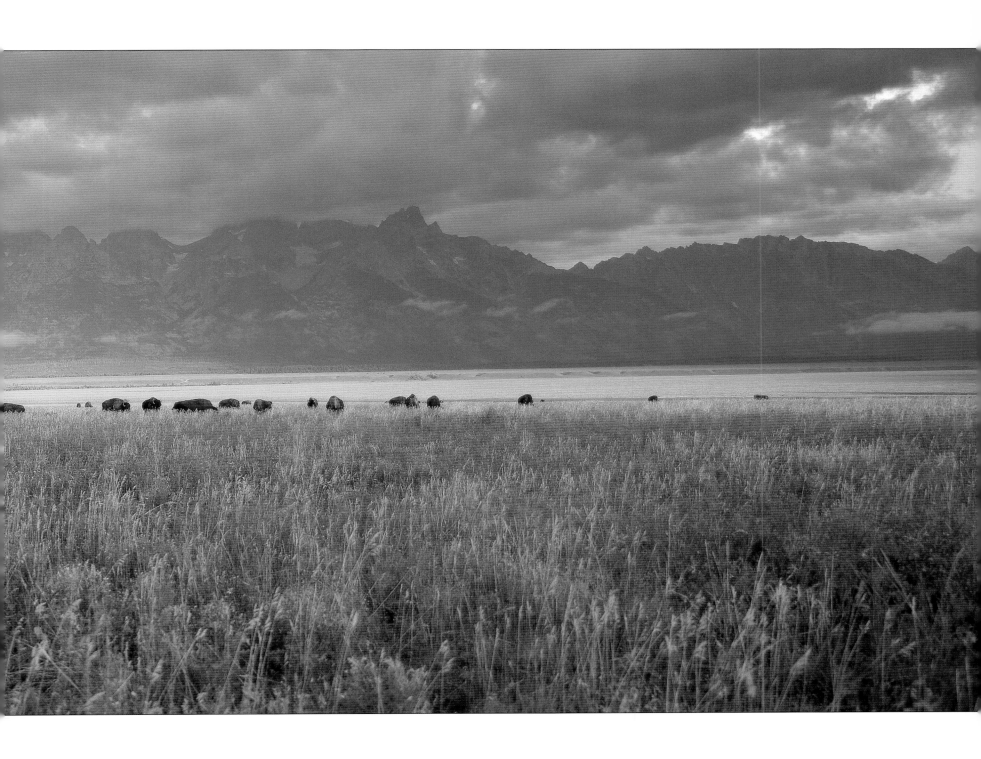

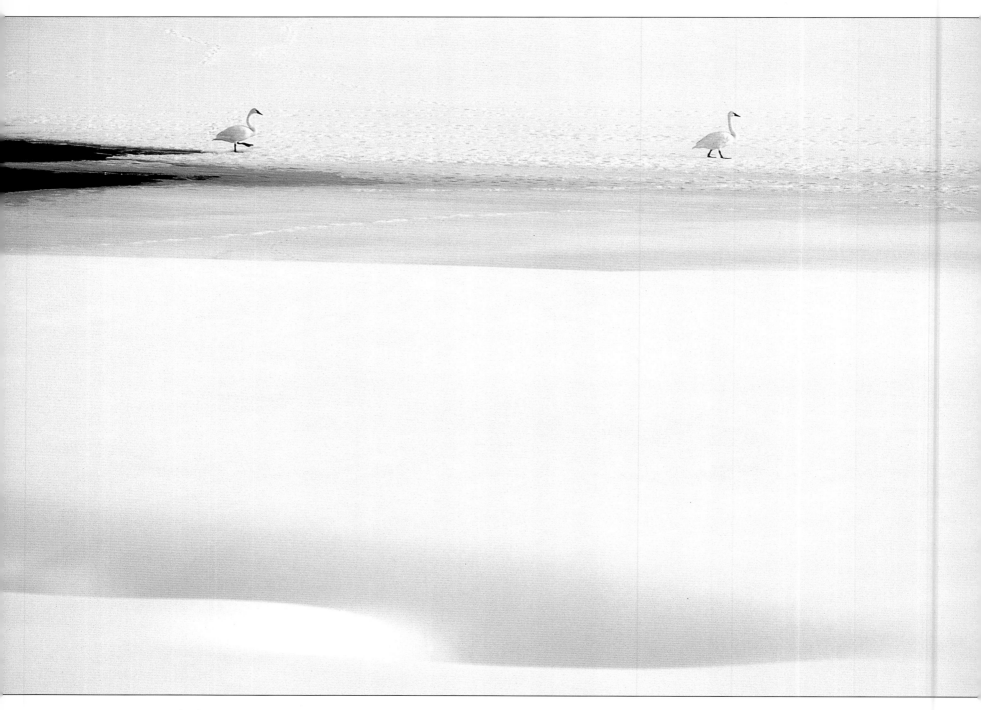

Trumpeter swans that live here on the Snake River and in other parts of the Greater Yellowstone Ecosystem have never learned to migrate. The same isolated valleys that helped protect them from early hunters now make them vulnerable to harsh mountain winters. They will seek open water during a bitter cold snap, but will not fly south for the winter.

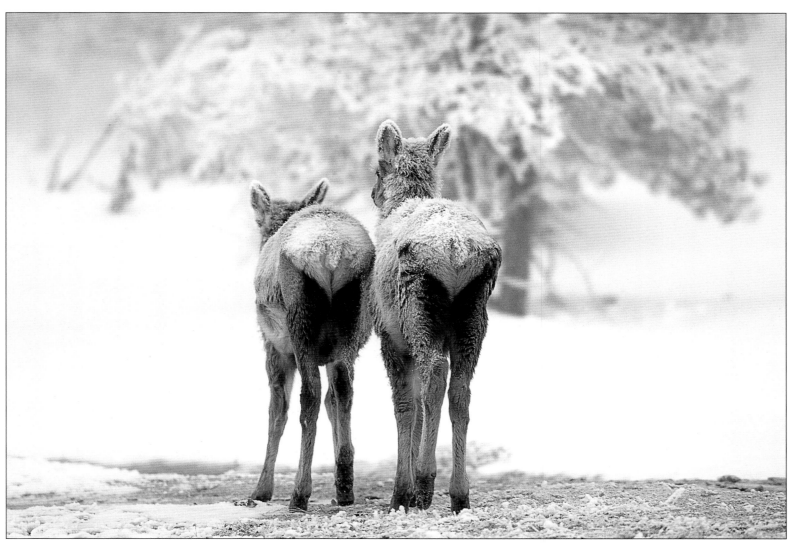

An elk cow and calf stroll off toward a meager meal of lodgepole pine needles on a frosty morning near Old Faithful.

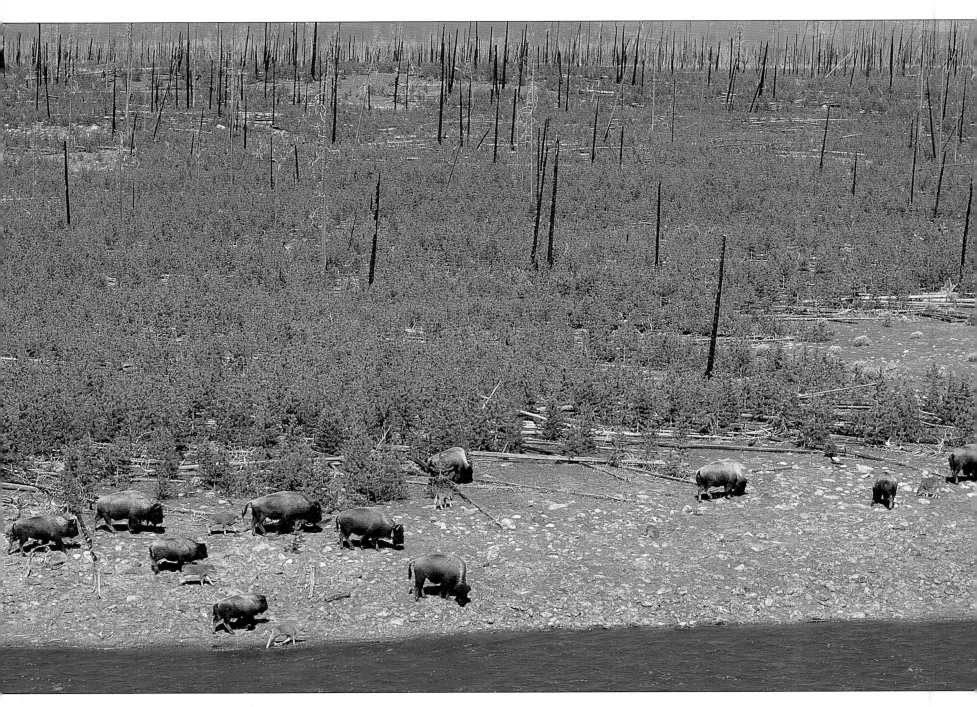

Next generation of bison and lodgepole pine appear together along the banks of the Madison River. Twelve years after the great fires of 1988, both the bison and the lodgepole pine live in a changed Yellowstone landscape, a natural sequence in the ecosystem's cycle.

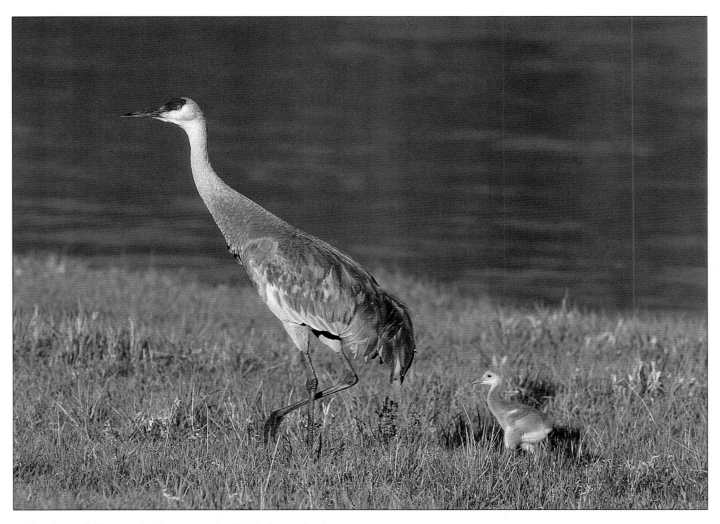

A female sandhill crane takes her two-week-old colt for a walk along the Buffalo River. Sandhills normally hatch two eggs each spring, but usually only one chick survives.

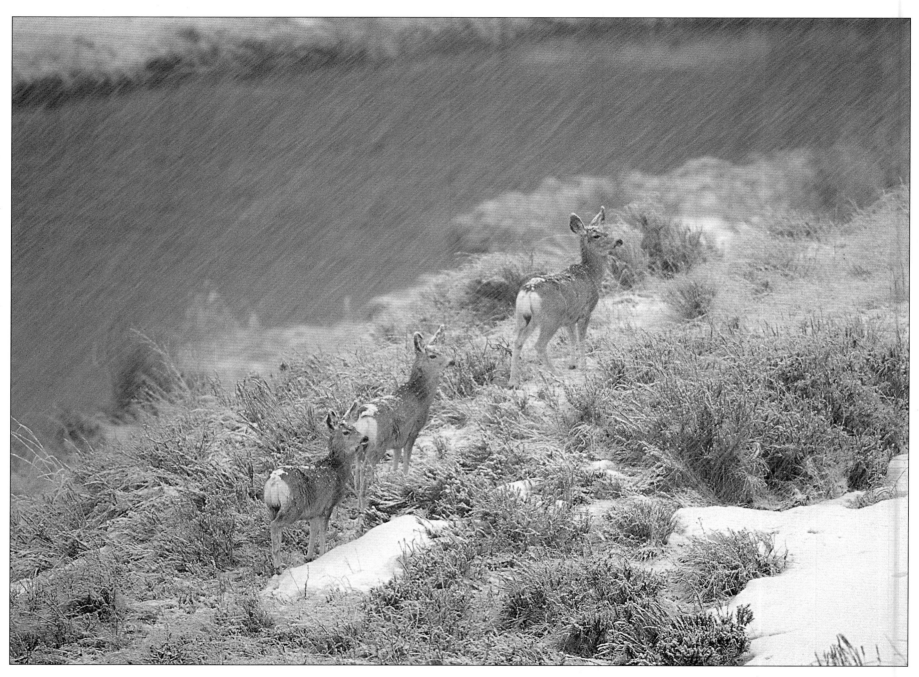

*April showers. A mule deer doe and her twin fawns are caught in a
late spring squall. Snow comes early to the high country and stays late.
It can snow on any day of the year, even the fourth of July.*

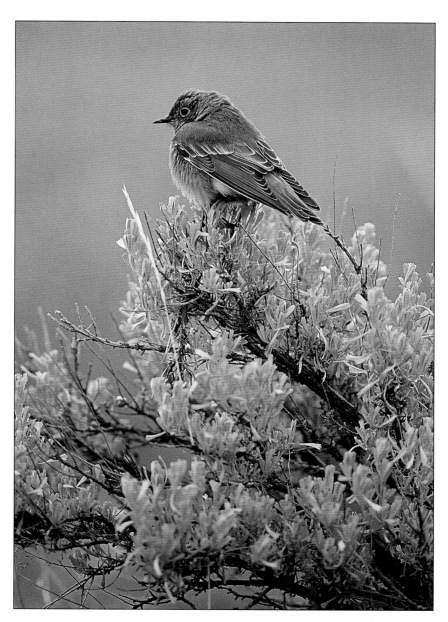

Although not yet as colorful as mature males, juvenile mountain bluebirds can often be seen as families gather before heading south. It is a special treat to be standing in the sage when fifty or more of these brilliant birds pass by at once.

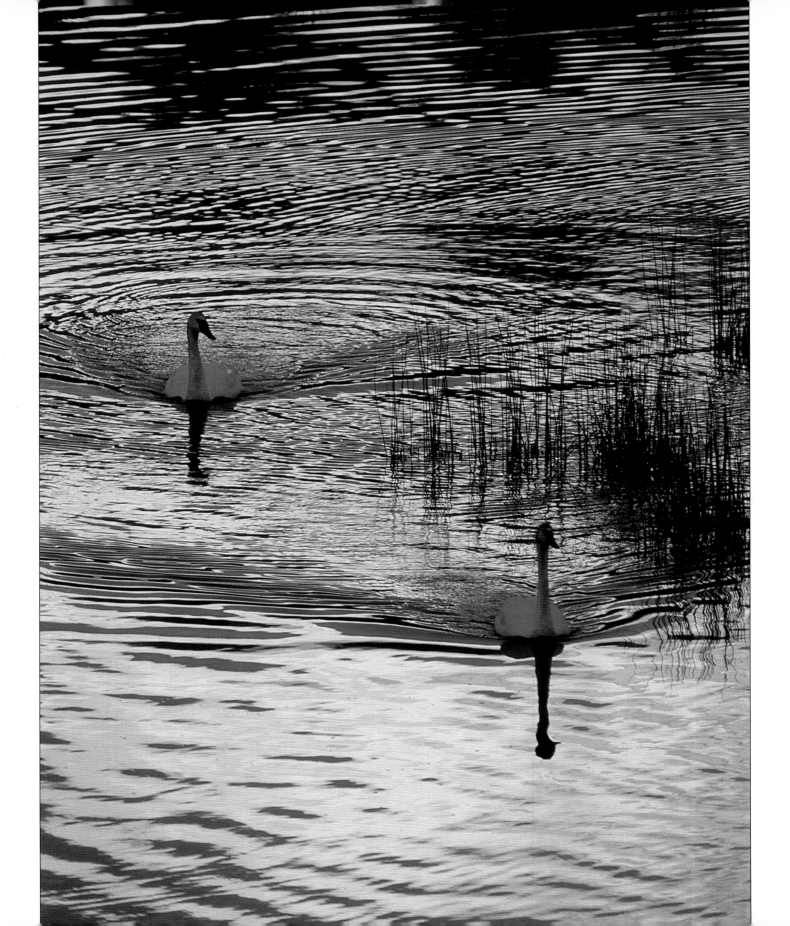

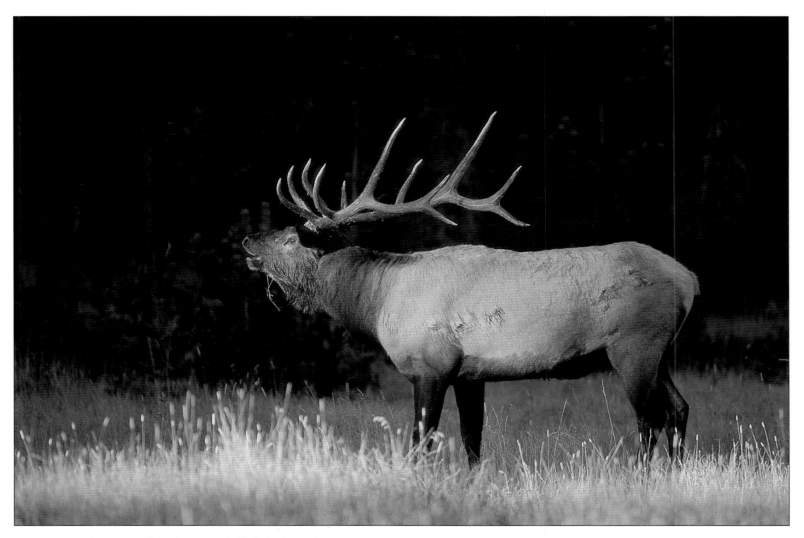

Above: Materializing out of the shadows, a bull elk bugles as the sun's rays fade. Elk spend much of the early morning and late evening hours in the open meadows of both parks, but head for shade during the heat of the day.

Facing page: The largest of all North America waterfowl, trumpeter swans mate for life, and return each spring to the same nesting sites. Yellowstone Country's small ponds and lakes make excellent nesting sites for these stately birds.

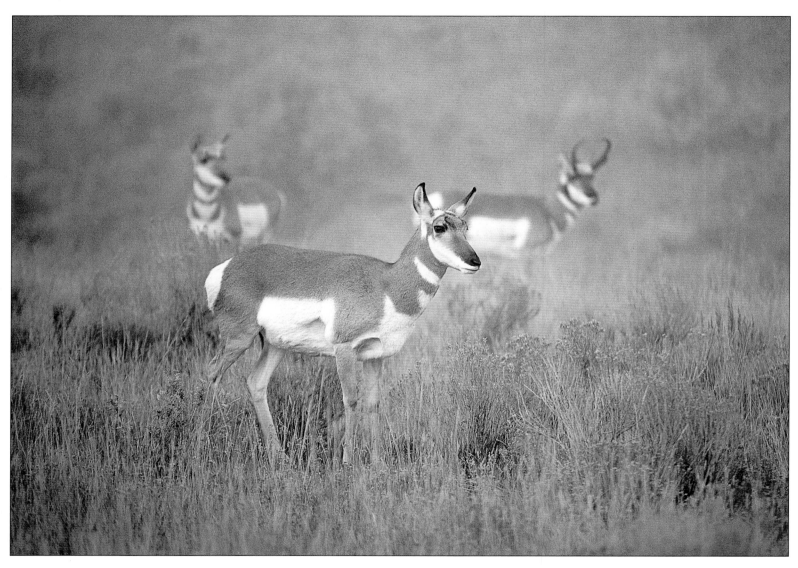

During the mating season, a pronghorn buck will do his best to fend off other males and keep a small band of does together. The pronghorn rut usually starts in late August and runs through September.

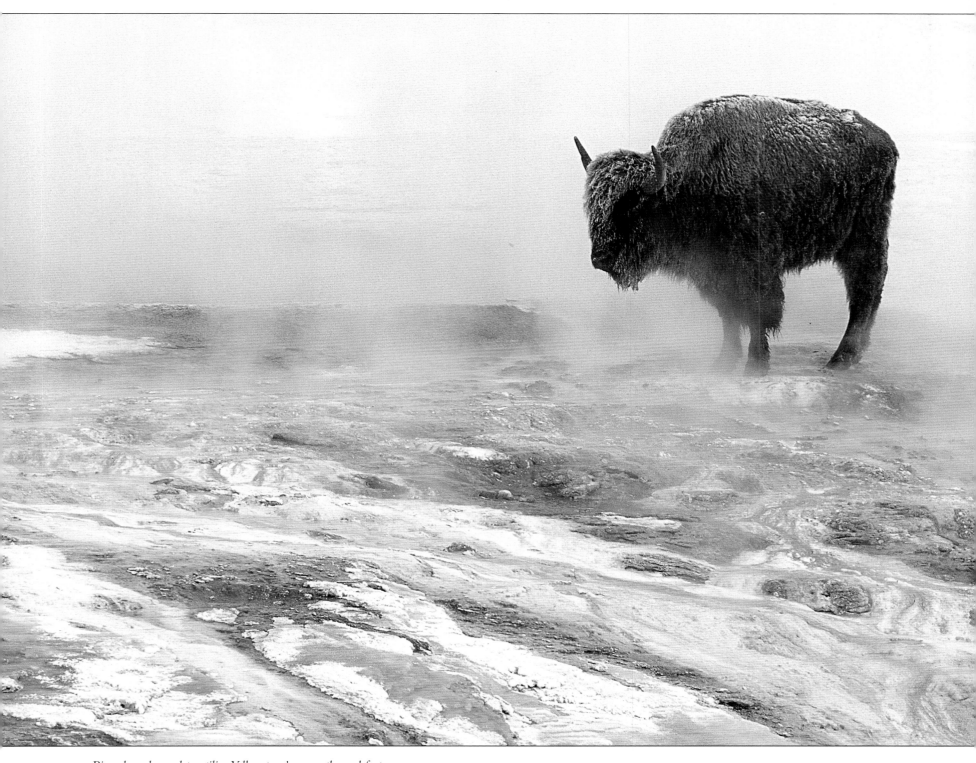

Bison have learned to utilize Yellowstone's many thermal features to help them stay warm during long winter nights.

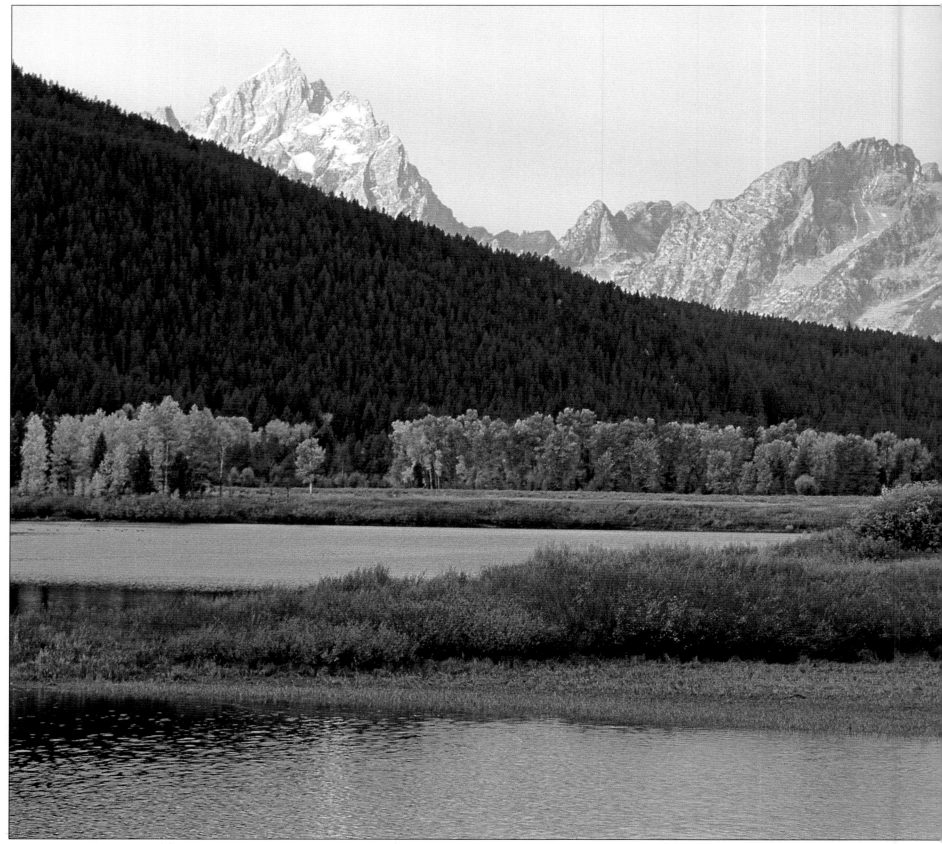

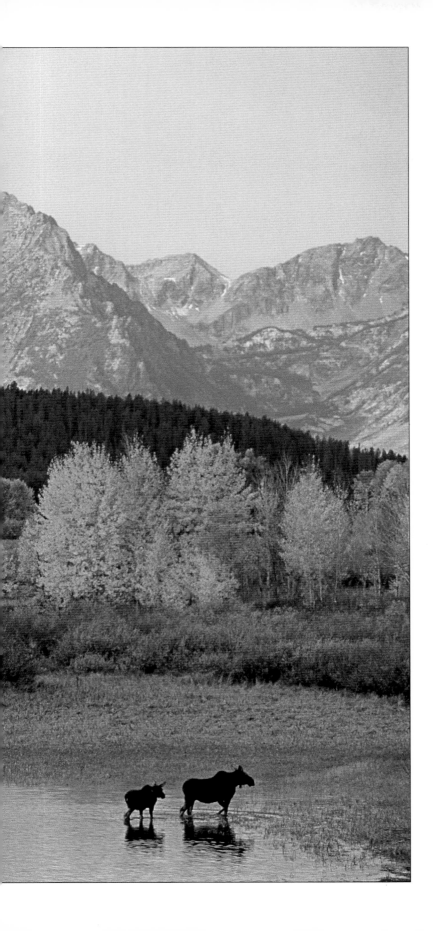

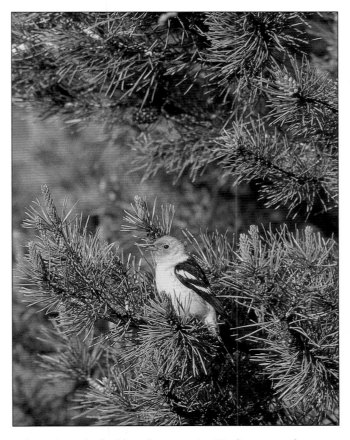

Above: A touch of gold in the mountains. To glimpse a male western tanager can be the bright spot of any day spent in the mountains.

Left: The beauty of fall surrounds a moose cow and calf as they wander through the shallows of the Snake River. Moose can usually be found wherever water is plentiful, such as here at Oxbow Bend.

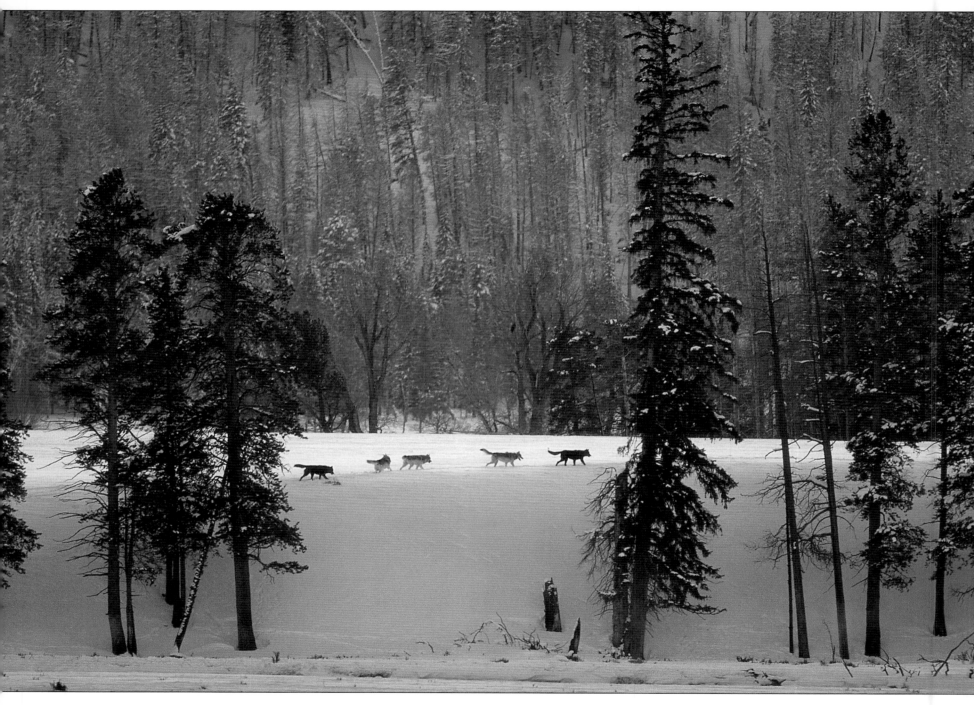

The Druid Peak Pack forms an impressive line above the banks of the Lamar River. The return of wolves—missing for more than seventy years—made the Greater Yellowstone Ecosystem complete once again in 1995. The drama of predator and prey unfolds daily in the Lamar Valley, perhaps the only place in the world people can witness true wolf behavior without leaving pavement. (DAN & CINDY HARTMAN PHOTO)

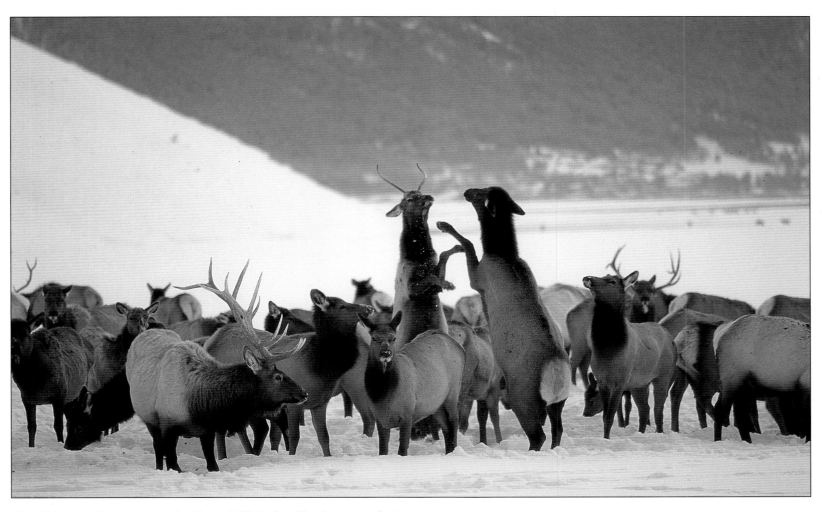

Two elk settle a disagreement on the National Elk Refuge. The deep snow of winter forces elk down from the high country and into closer quarters than they might like. As the town of Jackson grew, overlapping with historic elk winter range, the need to assist the elk became apparent. The refuge was established in 1912 and now serves as a wintering ground for between 7,000 and 14,000 elk.

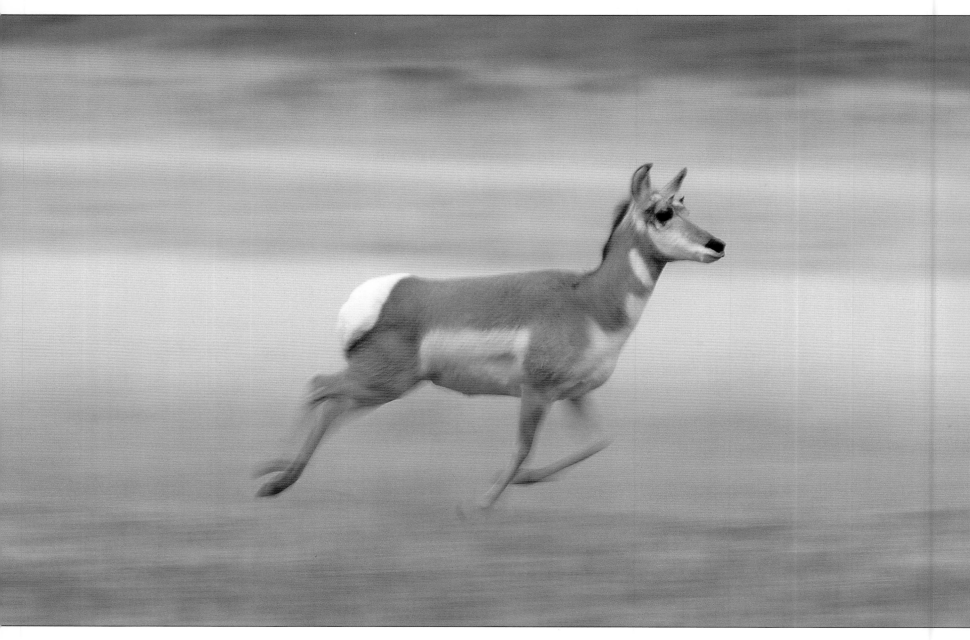

Born to run, a pronghorn speeds across the grasslands of Northern Yellowstone.
The fastest animal in the Western Hemisphere, the pronghorn can reach speeds
up to seventy miles per hour. Such swiftness serves pronghorns well when they
are avoiding predators on the open plains.

Right: The beating wings of a broad-tailed hummingbird slow just long enough for this male to light. Hummingbirds are one of the smallest and most beautiful members of the animal community. You are more likely to hear a broad-tailed than see it: the wings make a distinct buzzing sound when it flies. The broad-tailed and the smaller calliope are the two most common hummingbirds in the region.

Below: This meadow near Tower Junction is also known as Blacktail Deer Plateau, another name for mule deer like these. The northern portion of Yellowstone is an excellent place to find these beautiful creatures.

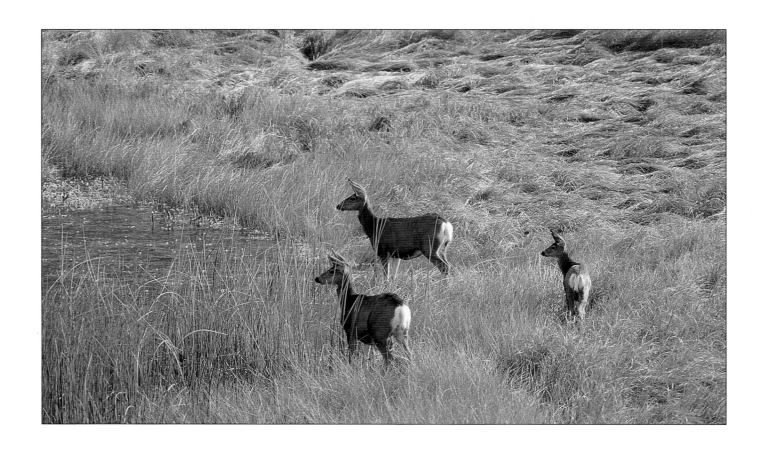

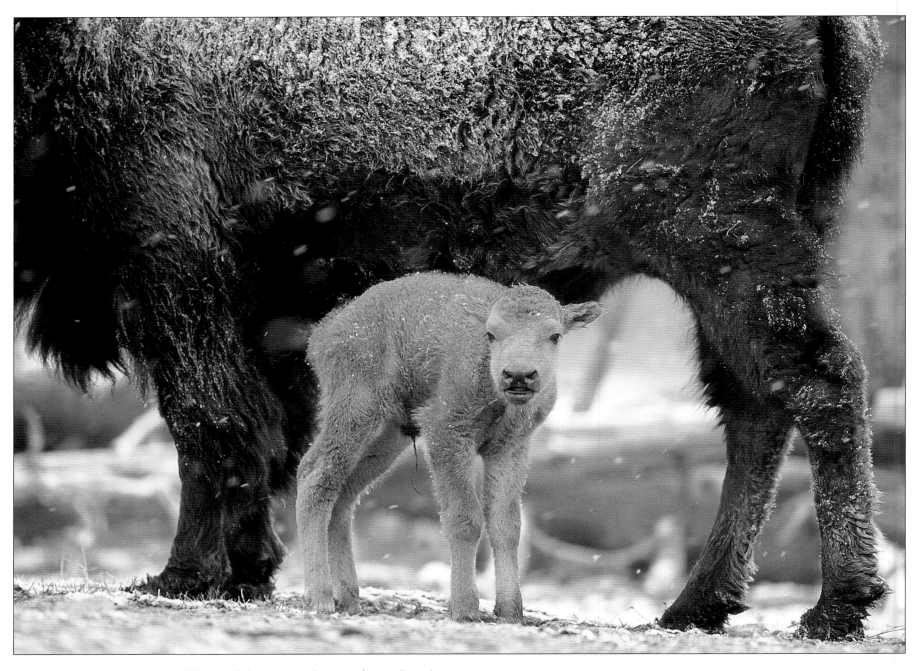

Spring snow keeps a day-old bison calf close to its mother. Born from mid-April to late May, these little orange balls of energy can be seen frolicking together in many of the park's grassy meadows.

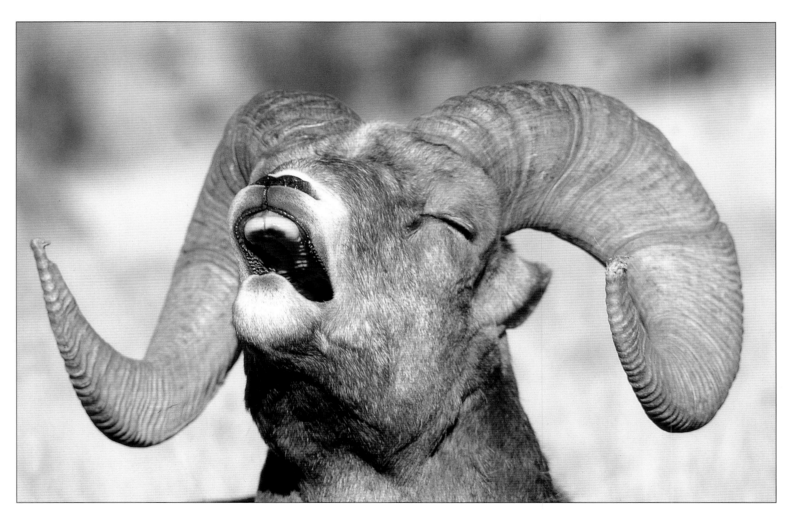

This bighorn sheep ram's apparent burst of song is really a big yawn. With horns that add another ring each year, it is possible to tell the age of a ram by the size of his curl. Unlike antlers, which drop and regrow each year, horns are permanent and keep developing.

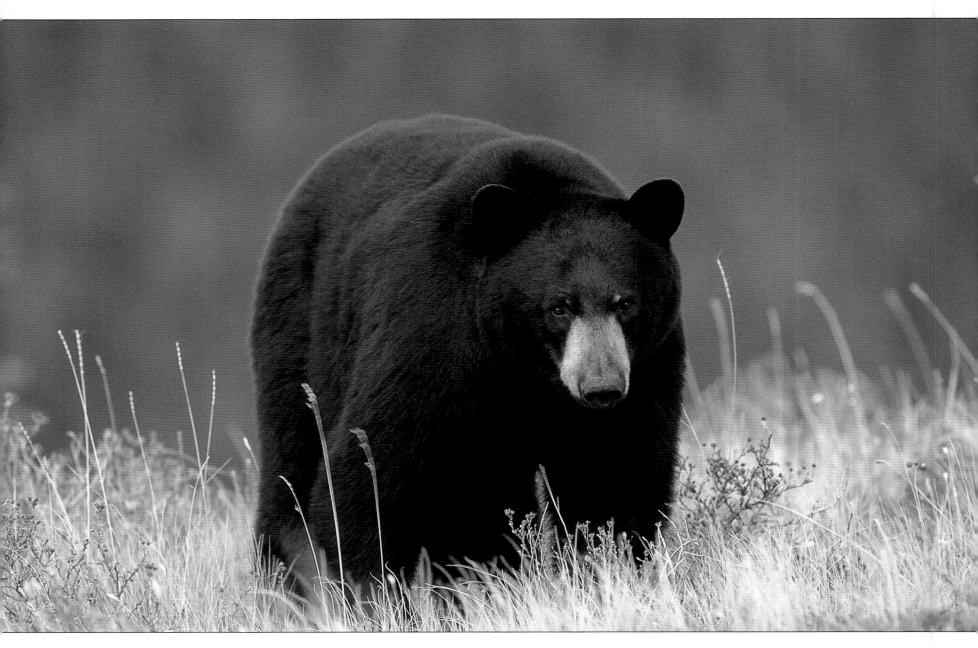

This large male black bear is in his prime by late fall. Distinguishable from the grizzly by its flatter, less dished face, and the lack of a distinct shoulder hump, the black bear is mostly a forest dweller, while the grizzly prefers open plains. The black bear also has shorter claws, making it well suited to climb trees. (RICK KONRAD PHOTO)

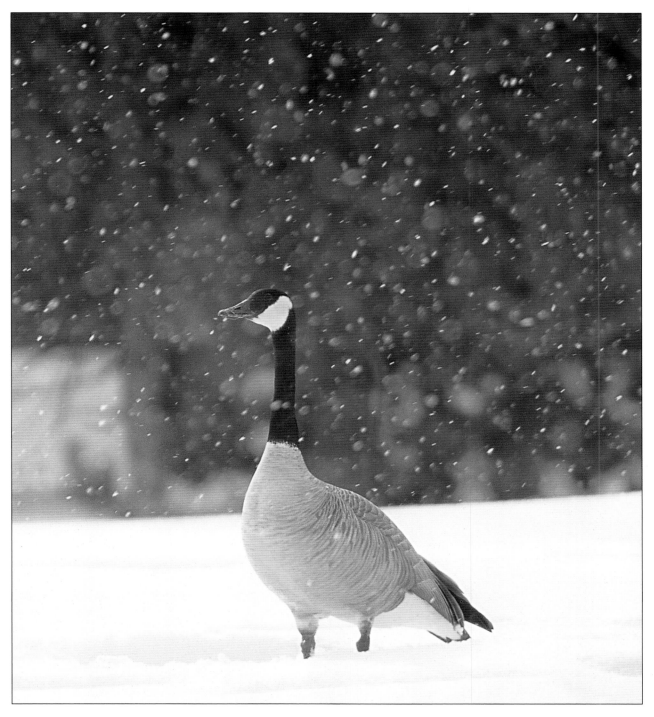

Most Canada geese head south at the first sign of snow. However, in Yellowstone Park, a few hardy geese have adapted to using waterways that never freeze all winter. Due to a large volume of runoff from the many geysers and hot springs, rivers such as the Firehole and the Madison stay open year-round. Even though winter temperatures routinely reach 40 degrees below zero, waterfowl find food in the ice-free channels.

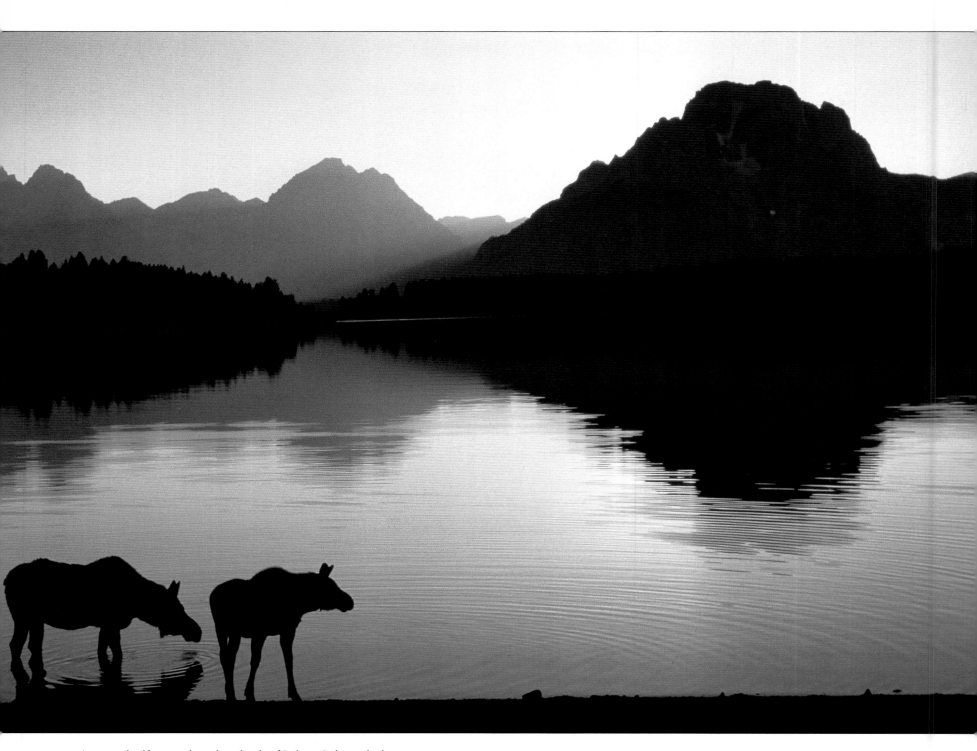

A cow and calf moose share the solitude of Jackson Lake as the last rays of sun slip behind Mount Moran.

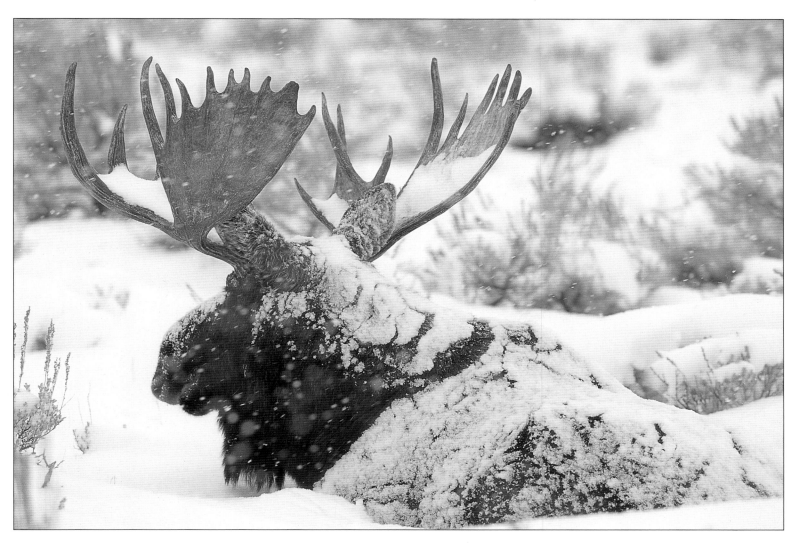

The sagebrush flats of Grand Teton National Park are an excellent place to find moose, like this bull, when the snow flies. Sagebrush makes up an important part of a moose's winter diet.

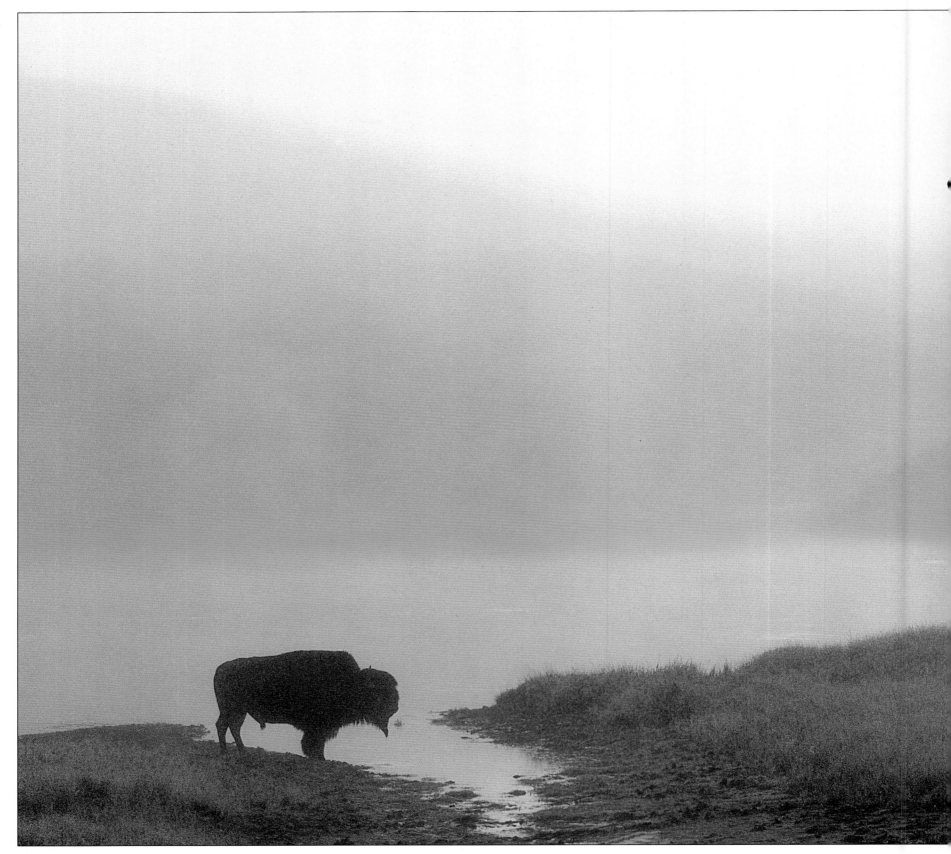

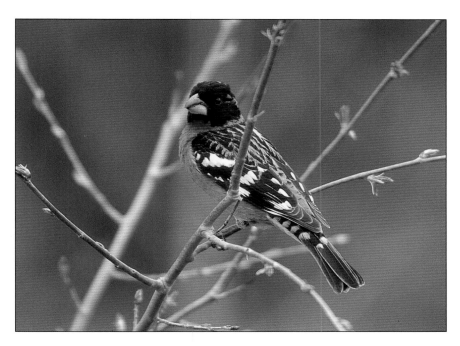

Above: A male black-headed grosbeak finds a perch in an aspen tree. Arriving to breed in late May or early June, this species is a colorful addition to summer in the mountains.

Left: Even though bison are normally herd animals, the occasional bachelor, like this fellow at the Yellowstone River, may be found.

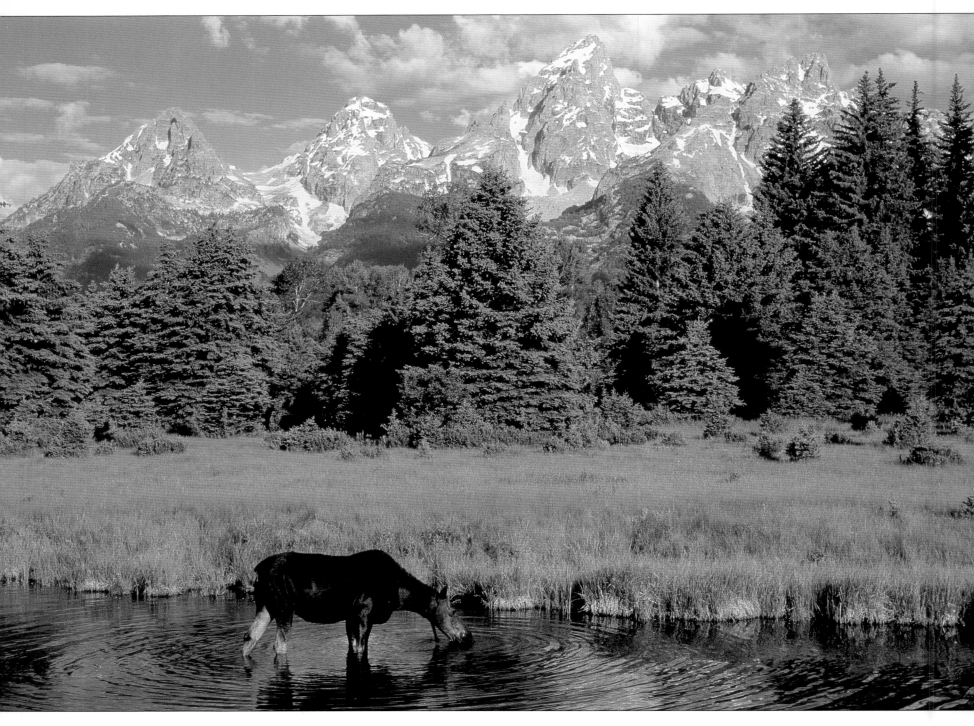

Moose are excellent swimmers with long legs designed for deep winter snow, and for enjoying cool water such as the Snake River.

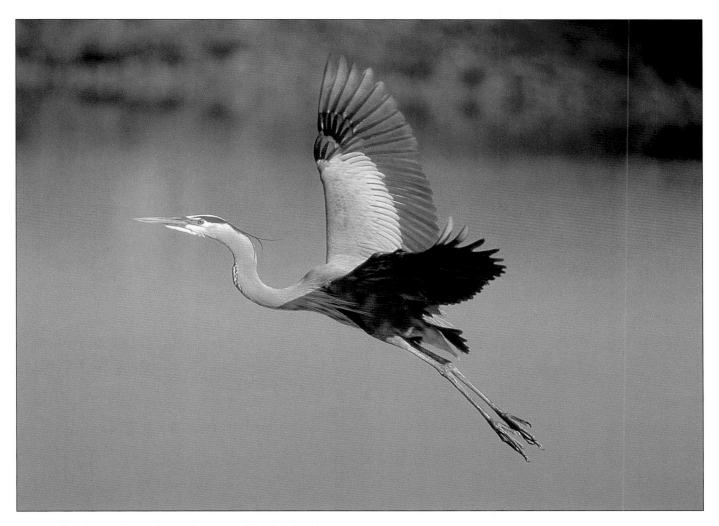

A great blue heron takes to the air dressed in all his breeding finery.
Several heron rookeries, hidden along the Snake River, are where
these long-legged waders return each year to nest.

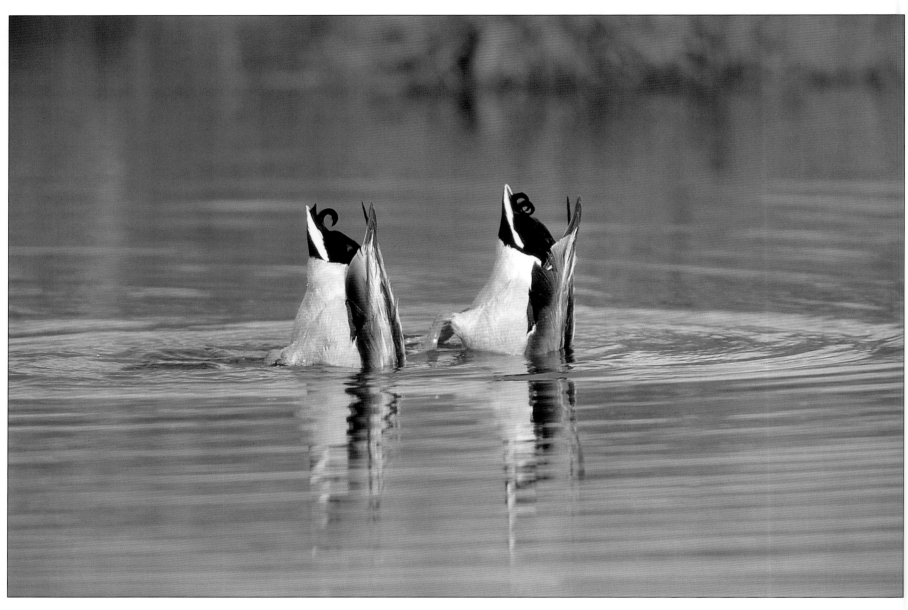

Bottoms up? A pair of male mallards signal the end is near!